*From David T.
To David T. Enjoy*

OSWESTRY

THROUGH TIME

David Trumper

David Trumper

30th June 2018

AMBERLEY

With love to my daughter Vicki, for what you achieved academically in 2017.

First published 2018

Amberley Publishing
The Hill, Stroud, Gloucestershire, GL5 4EP
www.amberley-books.com

Copyright © David Trumper, 2018

The right of David Trumper to be identified as the Author
of this work has been asserted in accordance with the
Copyrights, Designs and Patents Act 1988.

ISBN 978 1 4456 7358 5 (print)
ISBN 978 1 4456 7359 2 (ebook)

British Library Cataloguing in Publication Data.
A catalogue record for this book is available from the
British Library.

Origination by Amberley Publishing.
Printed in Great Britain.

Introduction

The town of Oswestry is situated in the north-west of Shropshire, close to the border of England and Wales. The town dates back to the Norman period, but just to the north is the Iron Age hill fort known as Old Oswestry. The fort was also known as Hen Dinas and dates from around 250 BC. It was abandoned soon after the Roman conquest but reoccupied after the Romans left. According to local legend, Guinevere, the wife of King Arthur, was born there. In AD 642 King Oswald of Northumberland lost the Battle of Maserfield to King Penda of Mercia. He was captured and his body was nailed to a tree known as St Oswald's Tree, from which the name of the town is derived.

After the invasion of 1066 the Normans built a castle on a mound, still visible behind the Guildhall, around which the town of Oswestry grew up. The outer bailey has been built over, but the name still survives in Bailey Street and Bailey Head. In the eleventh century, William Fitzalan was lord of the manor and in 1228 the town was granted its first charter. The town prospered, but being close to the Welsh border meant that the threat of hostility was never far away. In 1148, Oswestry was in Welsh hands as it was recorded that King Madog rebuilt the castle. In 1215, King John burnt the castle and part of the town in revenge against John Fitzalan, who had sided against him. The town was also burnt to the ground in 1233 by Llewellyn the Great and later by Owain Glyndwr. Several accidental fires also devastated the town, the most severe in 1567, which destroyed over 200 houses. Serious damage was done to the town during the Civil War. At the beginning it was in Royalist hands, but was captured by the Parliamentary forces and held despite several attempts to recover it. After the Civil War Cromwell ordered the destruction of the castle and other fortifications in the town.

With the Restoration, Charles II granted Oswestry a new charter confirming similar rights to the one held before the Civil War. With peace along the border, the town settled down to thrive as a market town serving a large hinterland where it was an advantage for traders to have knowledge of the Welsh language.

Oswestry flourished throughout the nineteenth century, especially after the arrival of the railway, when the population almost doubled and hundreds of new houses were built. The Cambrian Railway, which was later incorporated into the Great

Western Railway, set up a large locomotive, carriage and wagon works. It brought a great deal of prosperity to the town until it closed in 1964. Today, Oswestry is still a thriving market town, with its shops and open markets attracting visitors from far and wide. Due to its close proximity to the Welsh border, the town is also known as the Gateway to North Wales.

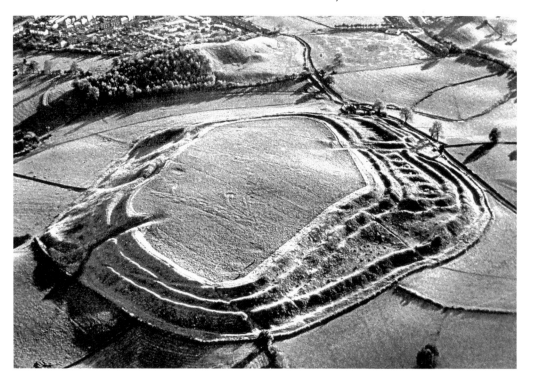

Old Oswestry from the air.

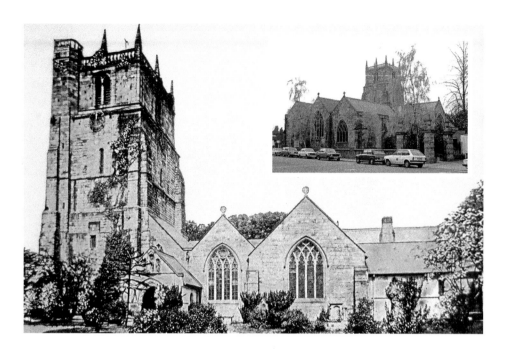

St Oswald's Church

St Oswald's is the parish church of Oswestry and it has had a rather chequered history. Parts of the church date back to the thirteenth century, but it was severely damaged due to two skirmishes during the Civil War and was almost completely rebuilt in a Perpendicular style. It was heavily restored between 1872 and 1874 by the Victorian architect George Edmund Street, who was a leading practitioner of the Victorian Gothic Revival style. He was responsible for the attractive chancel and reredos. The exterior of the church has changed little since the early black-and-white photograph, which dates from around 1910. The main differences are in the churchyard, where the shrubs were replaced by silver birch trees in the 1970s, and by a more formal layout today.

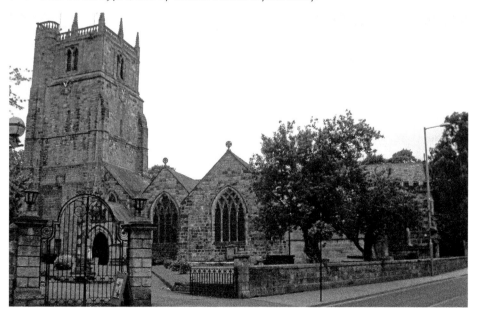

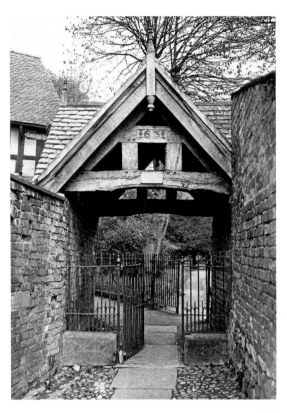

The Griddle Gate

This gateway, dating from 1631, was the original entrance into Oswestry School, founded by David Holbache in 1407. It is known locally as the Griddle Gate. There are two theories to its purpose: one is that it was used as a lychgate, where a coffin could be laid on a bier under the arch; the other is that there was a door at the far side with a grill in, so that the doorkeeper could see who wanted access to the school. Today it's a smart entrance into the churchyard and also to the Tourist Information Centre, which occupies the old Oswestry School.

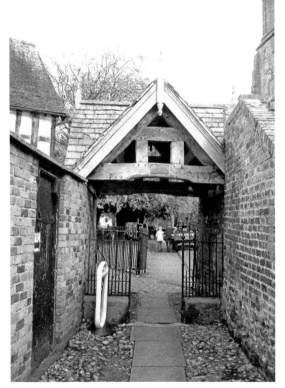

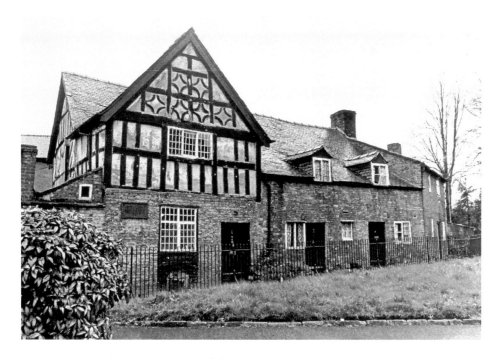

Old Oswestry School/Visitor and Exhibition Centre

The timber-framed building is the original Oswestry School, which was founded in 1407 by David Holbache. He was a wealthy landowner, lawyer and politician who was a Member of Parliament between 1406 and 1410. He left land situated in Oswestry to pay for a schoolmaster to run the newly established school, reputed to be the oldest grammar school in Shropshire. Early records show that a small part of the school fee was set aside for cockfighting to entertain the pupils. The school moved to new premises in 1776. The old building has also been used as a workhouse and a laundry before being adapted into cottages. By the 1970s it had become dilapidated, but it was restored and used as a toy museum until being converted into Oswestry Visitor and Exhibition Centre.

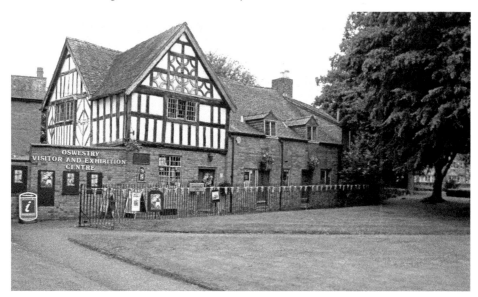

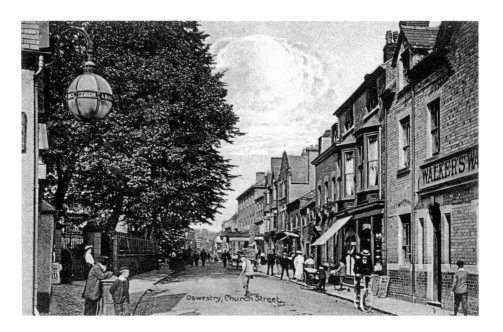

Church Street

This view of Church Street is looking down towards The Cross around 1910, when you could walk down the middle of the road in comparative safety. The church is on the left behind the trees, and in the distance on the right is the porched entrance to the Wynnstay Hotel. The building on the far right is the Sun Inn and the shop with the awning belonged to Miss Sarah Wilson, who was a stationer. Between the Sun Inn and the Wynnstay Hotel were two other inns, the Oak and the Bell – just three buildings from the Sun. The Bell Inn occupies a very old building, which was recorded in the parish register in 1663. The Sun has closed and is now a restaurant, but the Oak and the Bell are still in operation. The large globe lamp is on the side of the Coach & Dogs, and the large trees are in the churchyard.

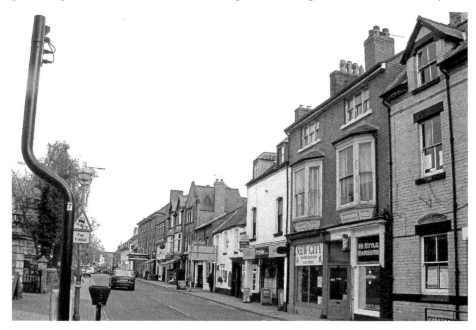

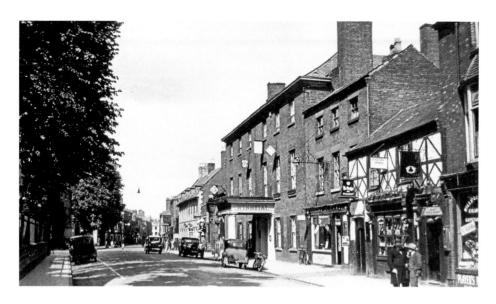

The Wynnstay Hotel

The Wynnstay Hotel is late Georgian in style and has a wonderful porch supported by two pairs of Tuscan columns that straddle the pavement. It was built for Sir Watkin William Wynn and when Sir Watkin married Lady Harriet in 1769 an ox was roasted on the land opposite the hotel as part of the celebrations. Two doors to the right is the Oak Inn, which was first mentioned in 1720 when it was occupied by brewer John Davies. For a short period in the eighteenth century it was known as the Royal Oak. Today the painted timber-framed frontage has been smartened up and a bow window has been inserted on the ground floor. The building between the hotel and inn was once an inn called the Albion, until 1876 when it was converted into a butcher's shop. It is now Wilsons Bar & Courtyard and attached to the hotel.

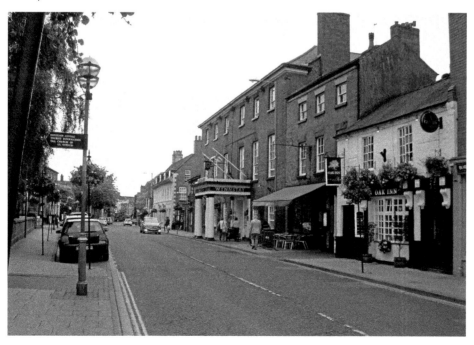

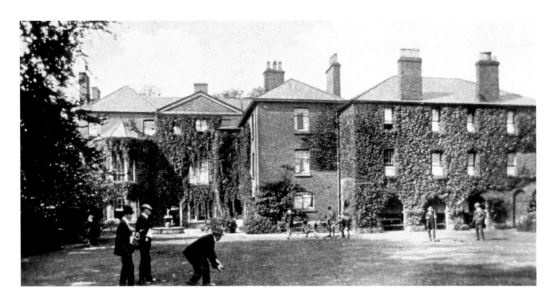

The Wynnstay Hotel Bowling Green

The Wynnstay Hotel has also been known as the Bowling Green and the Cross Foxes. In the 1901 census of inns and hotels, the Wynnstay was owned by Dame Louise Alexandra Williams Wynn but was managed by Charles Drew. It had ten rooms downstairs, thirty-seven upstairs, an assembly room and stabling for fifty horses. This photo is from a trade card for Mr Drew, whose family ran the hotel from around 1880 until just after the First World War, when it became a Trust House. The Drew family also ran a mineral water factory in King Street. The bowling green is still there and the game is still played throughout the summer months. A single-storey extension with a clock has been built in front of the three left-hand bays, while a fire escape has been fitted to the larger right-hand section. The ivy and most of the chimney stacks have been removed.

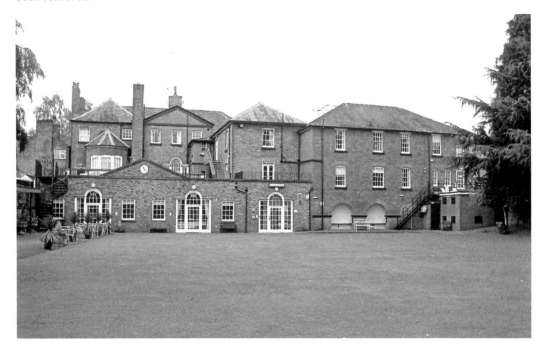

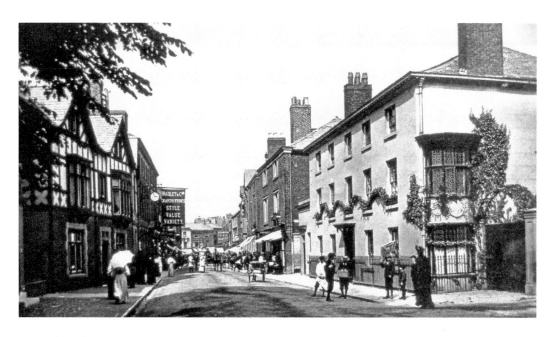

Church Street

The old photo, looking down Church Street towards The Cross, was taken in around 1905. The large house on the right was known as the Doctor's House and was the home of Dr Crofton at the beginning of the twentieth century. The timber-framed building on the left is Lloyds Bank and, just beyond, the building with the clock is the post office, which was opened in 1879 after moving from Willow Street. The clock was paid for by public subscription and was in memory of John Askew Roberts, a Justice of the Peace whose life 'seemed worthy of enduring record'. The large banner is outside Bradley's drapery shop, who advertised, 'Style, Variety, Value'. Today the Doctor's House has been demolished to create a car park and new shops in an area called Festival Square. A modern TSB Bank has been built on the site of Lloyds Bank.

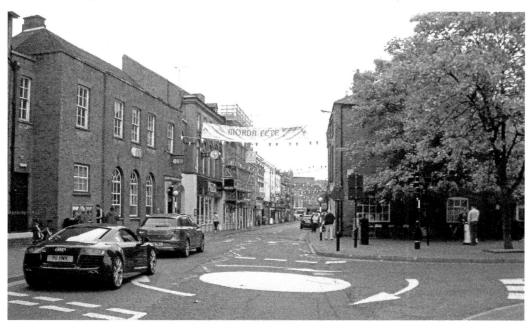

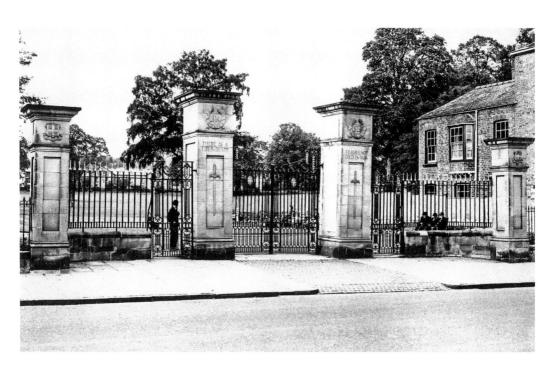

War Memorial Gates, Cae Glas Park

This is the entrance to Cae Glas Park, located off Church Street. The gateway was erected in 1921 and is a memorial to the men who sacrificed their lives during the two world wars. In the early years the area was mainly grass with pathways and seating for people to stroll and relax in. A bandstand was built, ornamental flower beds were added and a bowling green was opened in 1932. Today the entrance to the park is extremely colourful, with beautifully laid out flower beds providing a blaze of colour, which helped the town win a Gold Award in the Britain in Bloom competition in 2017. The building on the right is a side view of No. 34 Church Street.

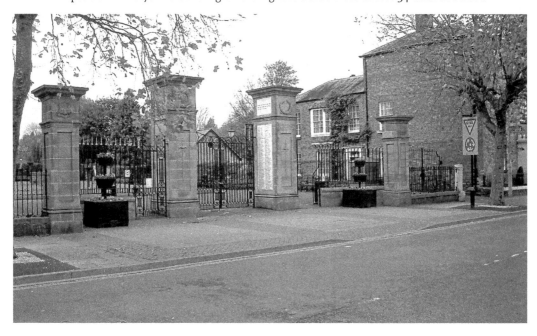

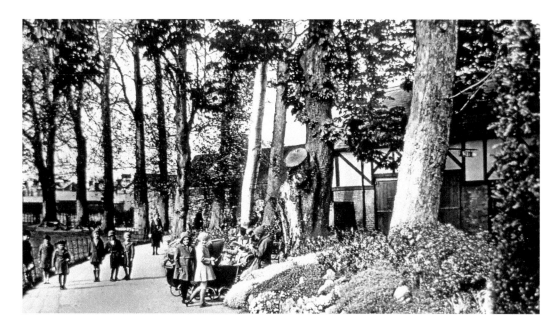

Cae Glas Park

The children in the old photograph of Cae Glas Park are fascinated by the photographer and his camera, but the adults sitting on the right studiously ignore him. The park was laid out on the site of Cae Glas Mansion, which was demolished around 1834. Charles Jones of Rossett was the owner of the land in 1908 and he offered it to the town council, provided they use it as a public park. It was bought for £6,000, but the seller generously donated £200 towards the landscaping of the grounds. The park was formally opened two years later on 23 June 1910. In 1998, a Heritage Lottery award was granted to enable major improvements in the park. The larger trees have been thinned out, a new children's playground erected and flower beds added to give another splash of colour to welcome visitors. In 2006, the Sports Village was opened, which allowed tennis, football, cricket and other sports to be practiced there.

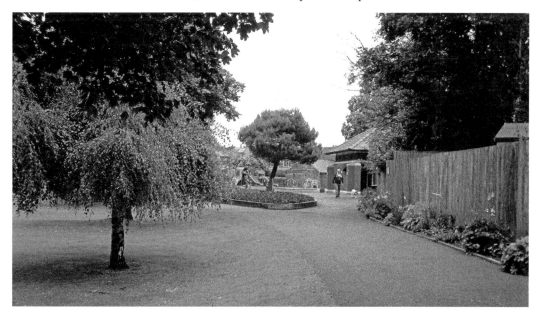

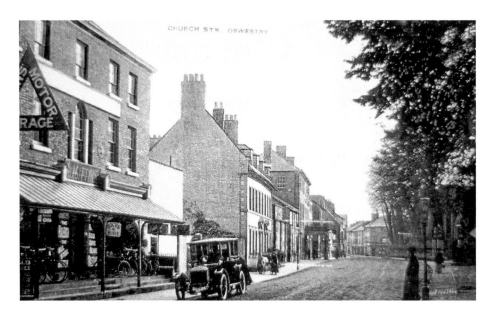

Gittins' Cycle Shop

This view of Church Street is looking back towards the Wynnstay Hotel, with the church visible behind the trees on the right. The car is parked outside a house called The Lawn that was built by the Croxon family, who came to Oswestry from Wrexham in the eighteenth century. It was bought by a Mr Owen Owen MA, who converted it into a high school for boys. It was later occupied by the Hotel Royal, owned by Charles Jones, who also catered for the local militia. At the beginning of the twentieth century the house was bought by E. J. Gittins, who opened a cycle shop there. By 1929 he was listed as a motor agent and had opened another branch of his business in Lower Brook Street. Today the house stands on the corner of Smithfield Street. It is now minus the porch that ran along the front of the building and the ground floor has been divided into two businesses, the Park Gate Florists and The Old Coffee Pot.

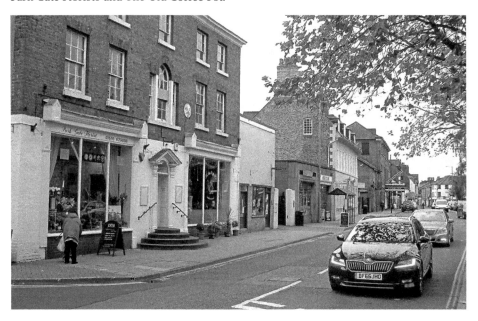

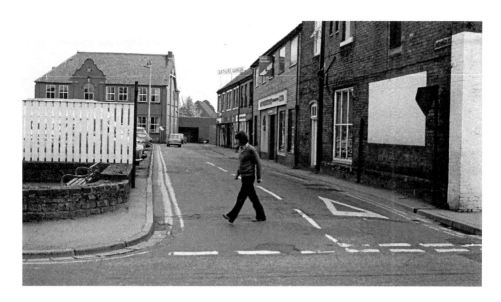

Smithfield Street

This is Smithfield Street, leading around to Smithfield Road and English Walls. The area was opened up with the demolition of the Doctor's House, shown on page 11. On the left is Festival Square and the large red-brick building at the end is the Memorial Hall. It was erected in 1905 by Sarah Parry Jones in memory of her sisters Jane Sides Davies and Anny Elizabeth Ridge, who died within a week of each other in March 1895. The hall now has eight rooms for hiring that will hold from 6 to 200 people. Just over thirty years separate the two photographs, but the view has been opened up and made more attractive with the planting of trees and the addition of benches, ornamental lamp posts and hanging baskets. The Park Gate Florist shop on the corner has put an entrance and windows in the side of the building. A mini island and traffic humps have been placed in the road to ease and calm the traffic flow.

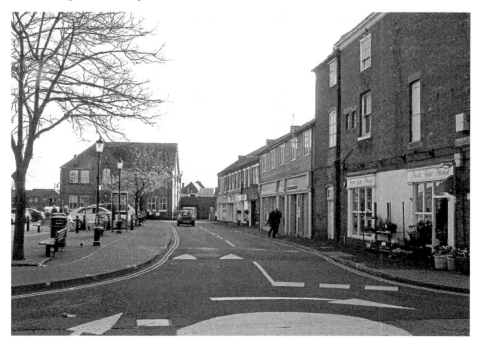

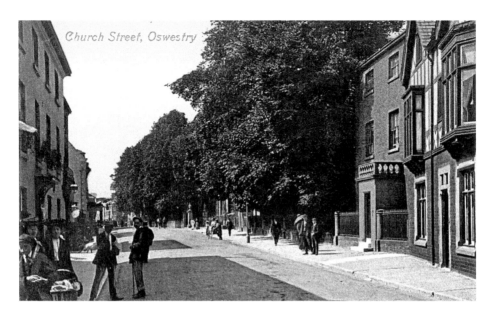

Church Street, Oswestry

Church Street

This view is looking back towards the junction of Upper Church Street. The large building on the left is the Doctor's House, which can be seen from the opposite direction on page 11. The trees at the top are in the churchyard, while the ones closer to the camera are at the entrance to Cae Glas Park. Just below the trees in the churchyard are the gates into the Broad Walk. The house on the right with the porch and balustrade is No. 34 Church Street. A similar house was built further up the road on the other side of the entrance of the park – both were erected around 1845. No. 34 was once occupied by William Bull, who came to Oswestry in 1835 to work for local solicitor R. J. Croxton. He later founded the law firm Messrs Bull & Sons. To the right is the mock timber-framed building belonging to Lloyds Bank. Most of the trees have been removed in the modern view, as has the Doctor's house, to form part of Festival Square, and the timber-framed bank has been replaced by a modern TSB Bank.

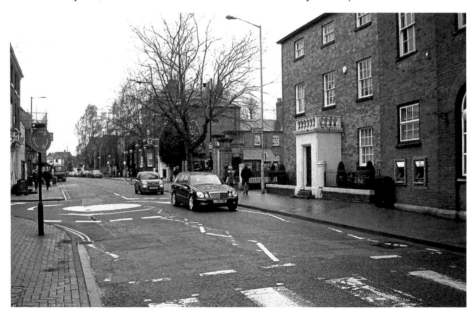

Clarke's Bakery, Church Street

Mr and Mrs Bertram Clarke pose outside their confectionery shop in Church Street, which they bought in around 1901. Although covered plaster, the building is reputed to be one of the oldest in the town. The plaque set into the gable is inscribed with the letter 'P' over the letters 'J E' and the date '1707', probably the year the timber frame was covered. The premises were first used as a bakery in 1831 by Edward Davies. He retired in 1866 and was followed by Samuel Withers, who sold the business four years later to Thomas Allmand, whose family ran the shop until 1901. The building has also been occupied by Smart's restaurant, café and snack bar, but at present it lies empty and is advertised to let. In the modern photograph the entrance has been moved to the right and a larger window inserted to the left.

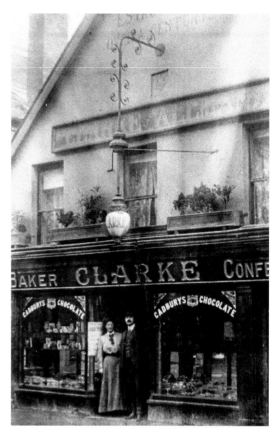

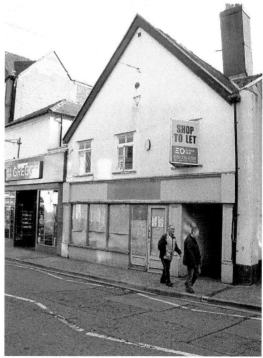

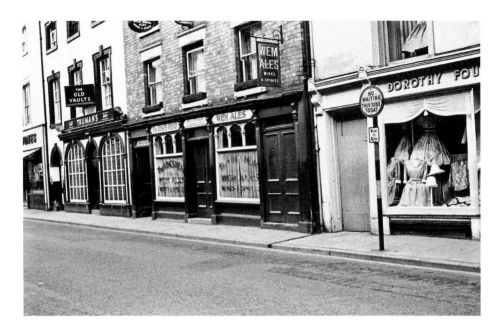

The Old Vaults and the Kings Head

Two inns stand side by side at Nos 12 and 14 Church Street. The first is the Old Vaults, which was established around 1770. In the 1950s, the landlord of the Vaults was James Alan Ball, the father of Alan Ball who played for England in the 1966 World Cup Final. He was also a professional footballer and managed several clubs, including Oswestry Town between 1954 and 1957. The Kings Head was first recorded in 1803 and although the frontage was rebuilt, the core of the building is much older. The building to the right was also an inn known as the Raven. Its licence lapsed around 1800, but in 1852 it was renewed for a short time and was known as the Prince of Wales. The building was converted into a shop before being demolished and replaced by a modern building.

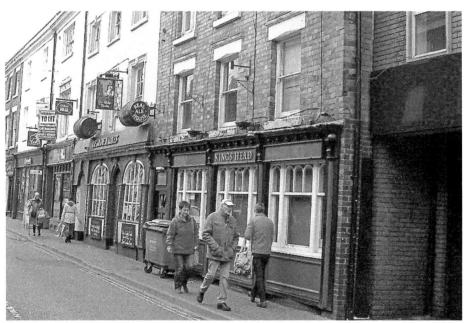

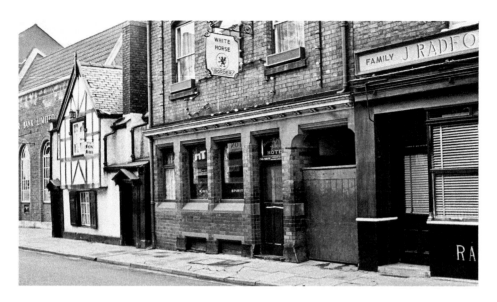

The Fox and the White Horse

Almost opposite the Old Vaults and the Kings Head were two more neighbouring licenced houses. In the timber-framed building was the Fox Inn, which was described by Isaac Watkin in 1920 as, 'A picturesque half-timbered building, with low ceilings, narrow passages, cosy corners, doors of cleft oak and a projecting gable that reached nearly across the side path.' Unfortunately the protruding part of the gable was taken away towards the end of the nineteenth century. The inn is very old, and was mentioned in 1707 when Edward Maurice paid rent for the house. To the right was the White Horse, which was refronted in 1872. The inn sign was preserved and can be seen on the modern view with its one front leg missing. The leg had been ripped off during Tory celebrations after the 1832 general election, and the knee joint of the leg was thrown through the window of a Liberal supporter who lived in The Cross. From the 1960s photograph to the present day, Radford's butcher's shop is still trading; the White Horse was later converted into a pharmacy, but now lies empty, and the Fox has also closed.

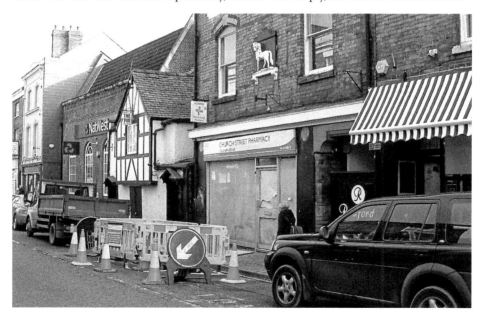

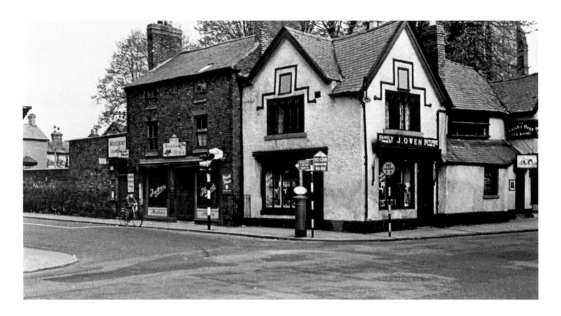

Upper Brook Street and Church Street

Local tradition states that the Coach & Dogs (seen on the corner) was built in around 1660 for Edward Lloyd of Llanforda, who drove around in a coach pulled by dogs. However, the register of listed buildings date it to the late sixteenth century with later additions and alterations. At one time it is thought to have been an inn and in around 1900 it was a temperance hotel. In the early photo the corner section is occupied by J. Owen, a family butcher, while the upper part in Church Street was occupied by the Coach and Dog Tea Rooms. The shop in Upper Brook Street was Marion's Stores. Note the advertising signs for Woodbine, Senior Service and Players cigarettes, which would be banned today. The post box and no-waiting sign have also been taken away and a fence has been erected to make pedestrians use the crossing. The traffic lights have also been moved further up the road.

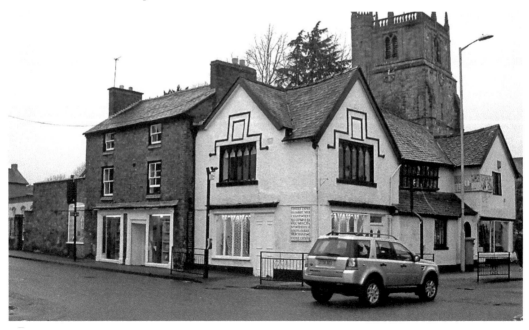

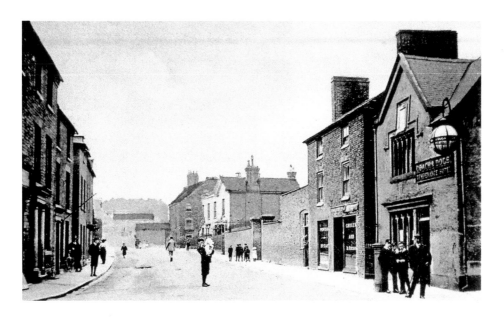

Upper Brook Street

This view of Upper Brook Street is looking towards Oswestry School from the junction of Church Street and Upper Church Street. Most of the buildings on both views are the same, except for the ones to the top right on the junction of Welsh Walls. The large house partly facing down the street is Lloran House, once the home of the Davies family, who owned the Lloran Ganol estate in the parish of Llansilin. It was later used for boarding pupils at Oswestry School, as a girls' school and as a social club for British Telecom before being demolished in the 1970s. The first building on the right is the Coach & Dogs – its magnificent gas lamp is on the corner. The pillar box was erected in 1859 but has been replaced by a pedestrian barrier and a pedestrian crossing at this very busy crossroads.

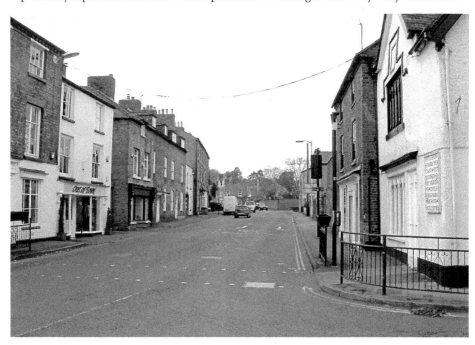

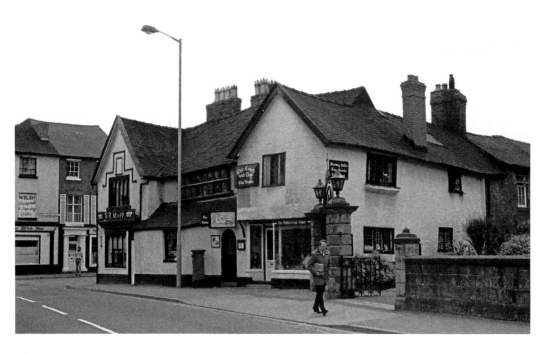

The Coach & Dogs

The old view of the Coach & Dogs from Church Street was taken in 1980 and apart from a few small changes the street scene has hardly altered. In the older view the tearooms are still there, advertising 'Lunches & Grills – Home Made Cake' and next door is a butcher's shop run by W. R. Mapp. Under the tearooms is the Golden Eagle antique shop. Across the road, on the corner of Upper Church Street and Upper Brook Street, is the Welsh Shop. It was run by J. W. and G. Ellis and sold a variety of goods, including Welsh tapestries, honeycomb quilts and Welsh tweeds. In an advert they gave their address as 'Welsh Shop Traffic Lights Oswestry'. Note the post box has been moved to this side of the Coach & Dogs.

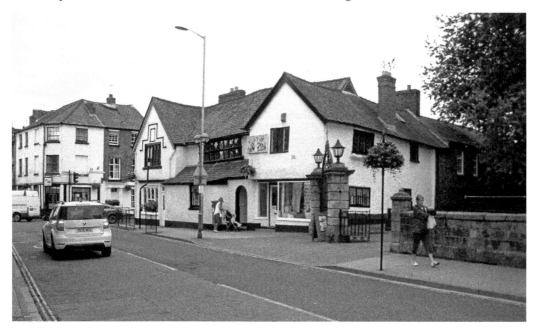

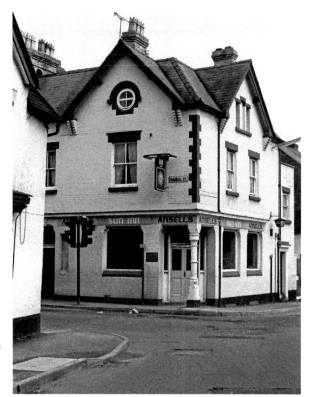

The Sun Inn/Brooks Restaurant
Opposite the Coach & Dogs, on the corner of Church Street and Lower Brook Street, was the Sun Inn, photographed above in 1980. The original Sun Inn was an ancient hostelry that was housed in a low timber-framed building on the same site. The old building was replaced around 1880 when it was owned and occupied by Robert Edwards. The inn is mentioned in parish records dating back to 1672 and 1685. A Friendly Society was founded there during the eighteenth century. After the pub closed, it was converted into a restaurant, initially known as Brooks Around the Corner – for obvious reasons. This was later shortened to Brooks Restaurant. Very little has changed, except for the street furniture and road markings.

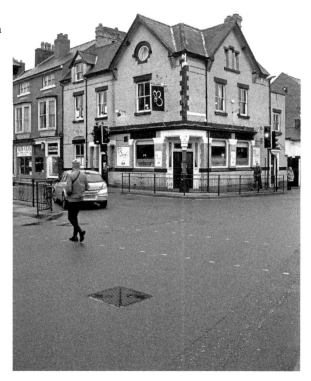

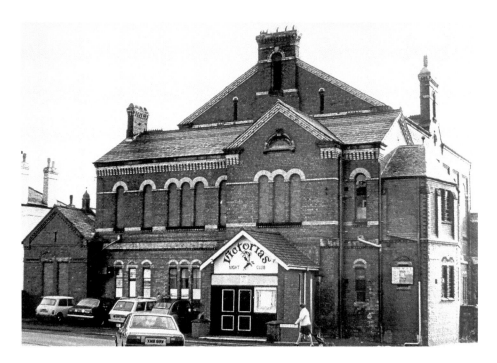

The Victoria Rooms

The Victoria Rooms stand on the corner of Roft Street and Victoria Road. It was built on the site of a timber and brick building that was used as a theatre from as early as 1775. This building was erected by a private liability company and opened by the Earl of Powis on 15 September 1864. On the upper floor there was an assembly room, measuring 70 feet long and 40 feet wide, with a smaller room on the ground floor. Both were available for theatrical performances, dances, concerts and other entertainment. The building also contained a billiard hall and a reading room belonging to the St Oswald Club. The building, known locally as 'The Vic', has now been turned into flats. In the present view the porchway has been removed, the windows have been opened up and the building to the left has been demolished.

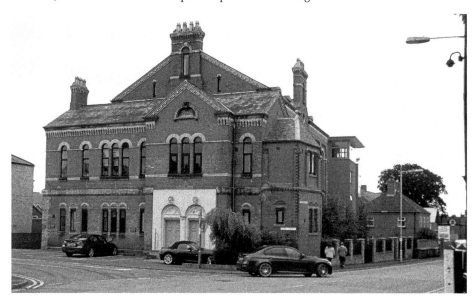

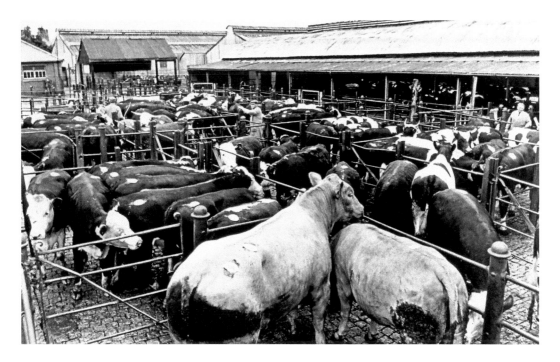

Oswestry Cattle Market

In Kelly's Directory of Shropshire it is noted that, 'In Oswestry the cattle markets and fairs are held on Wednesdays in the Smithfield, a piece of land covering about three acres. It was built on a field next to English Walls known as Cae Tomley, and was purchased by the Council from George Withers Edwards for £1050.' It was opened on 4 July 1849 and it was reported in 1855 that 'the market is exceedingly well attended and fully justifies the expectations of all parties engaged in its formation'. The old photograph was taken on 26 June 1968 and shows the first market to be held after the devastating foot-and-mouth epidemic that started in the area in October 1967. The market was moved to a site on Shrewsbury Road, which opened on 15 January 1969 and this area was cleared to become a car park.

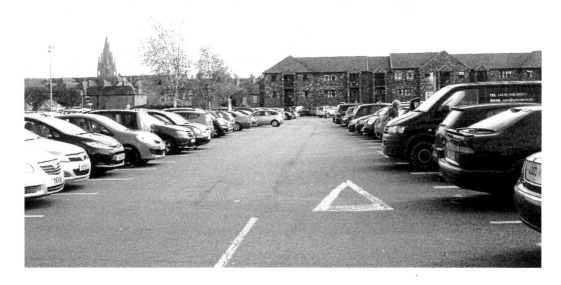

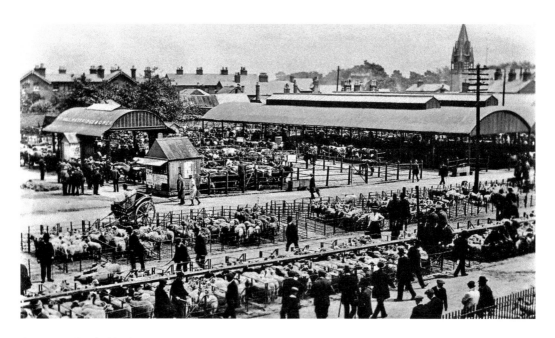

Oswestry Cattle Market

The photographer is looking over the cattle market towards Salop Road, with the spire of Holy Trinity Church visible on the far right. In 1856, a major overhaul of the market was started: a new south wall was built with iron railings on top, the whole market was paved with fire brick, additional iron pens for sheep and pigs were erected, and a pay room and two movable toll boxes were built. At the December sale of 1902, auctioneers T. Whitfield & Sons sold 231 fat cattle and 1,766 sheep and pigs. They also presented a silver cup to Mr F. B. Owen for the best fat bull of any breed at the market. The new photograph shows how well the car park is used, being so conveniently situated in the centre of town.

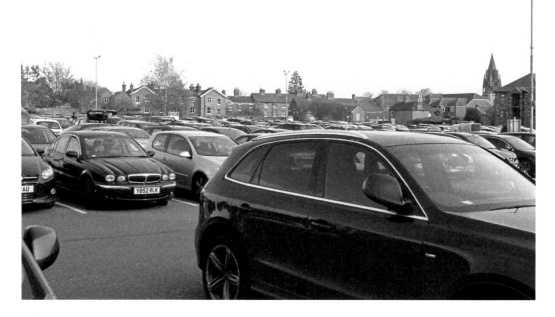

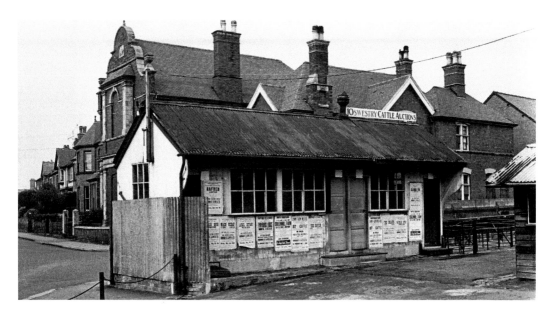

Oswestry Masonic Hall

This was the entrance into the cattle market on the corner of Roft Street. Behind the cattle market building is Oswestry's Freemason's Hall, used by three Lodges in the town. The foundation stone was laid by Provincial Grand Master Sir Offley Wakeman on 17 October 1901 before an audience of Freemasons, civic dignitaries and townspeople. A time capsule containing copies of the *Border Counties Advertiser*, *The Liverpool Courier* and *The Times*, together with a set of coins dated 1901 were placed in a cavity of the stone. The hall was formally opened on 24 June 1902. This is now the main exit from the car park, with the silver birch tree replacing the market building and giving a better view of the hall.

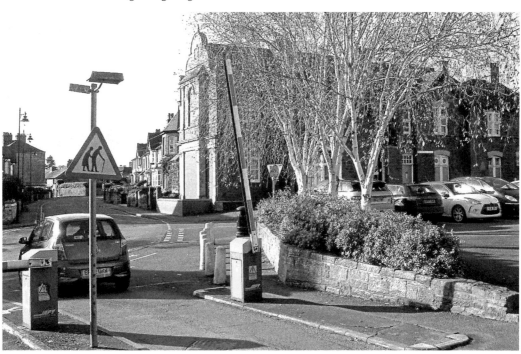

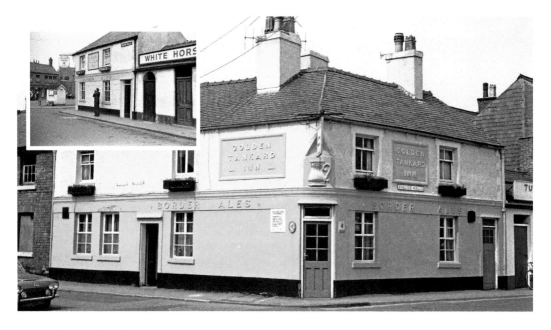

The Golden Tankard/Oswestrian Inn

The two public houses standing alongside each other on English Walls were the Golden Tankard Inn and the White Horse Vaults. In 1901, they were both owned by Dorsett Owen & Co. brewery. The Golden Tankard was first recorded in around 1840. There were five rooms on the ground floor and six upstairs, but no stabling facilities. On 22 July 1899 the landlord was convicted for selling alcohol to children under the age of thirteen. Since these 1960s and 1980s photographs were taken, the name has been changed – first to the Park and then to the Oswestrian. The corner door and the wonderful tankard above it have also disappeared. The White Horse Vaults was a much smaller inn. It was first licenced around 1870 and had only two rooms. A footnote at the end of the 1901 census reveals that 'The Vaults are only used on Wednesdays for accommodation of persons attending Smithfield'. Since closing as an inn it has had a second storey added and is now known as The White Horse Café.

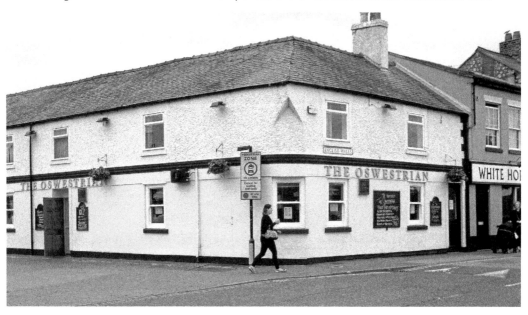

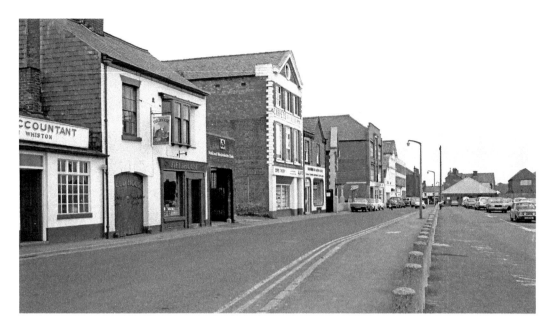

English Walls

This view of English Walls is looking towards the junction of Leg Street and Salop Road, with the old cattle market car park visible on the right. Before the cattle market closed, several of the buildings on the left were associated with the farming industry and were occupied by auctioneers, the National Farmers' Union and the National Farmers' Union Insurance Co. By 1980, the Vaults (on the left) was occupied by a turf accountant. Next door is Fieldhouse's shop, which sold household goods. There is also an entrance to the National Westminster Bank. The building next door to this has estate agent D. R. S. Parry on the ground floor and Carpets by Alan above. The bollards on the car park side have been replaced and the street has been made much more attractive by the building of a wall and the planting of flowers, shrubs and trees.

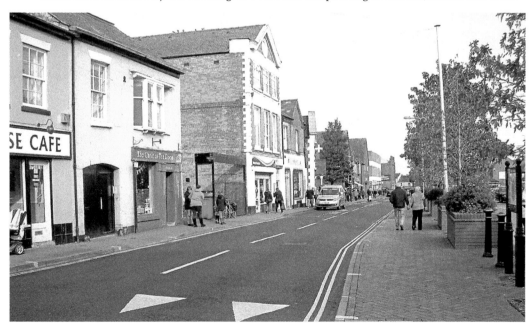

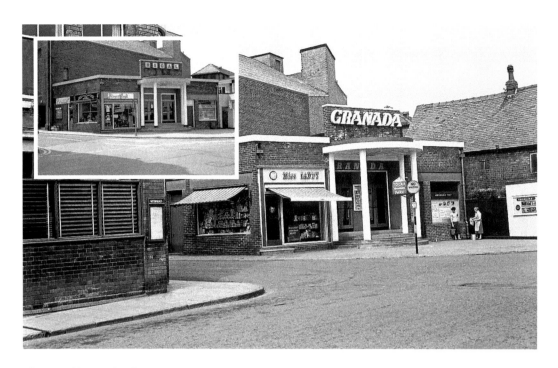

The Regal/Granada Cinema

This is the junction of English Walls on the left and Leg Street to the right. On the corner was a cinema, which was opened as the Regal on 22 May 1933. The first film shown was *A Successful Calamity,* starring George Arliss, Mary Astor and Randolph Scott. In 1956, the cinema was upgraded and reopened on 23 May as the Granada, before reverting back to its original name by 1980. It was built on the site of the original Bear Hotel and the Dorsett Owen Brewery in 1932. In 1960, the shop to the left was a Miss Candy sweet shop, where picturegoers could stock up on treats before entering the cinema. By the 1980s it had become a florist called Flower Craft. The cinema closed in 1994 and was empty for several years before the Original Factory Shop opened there in 2015.

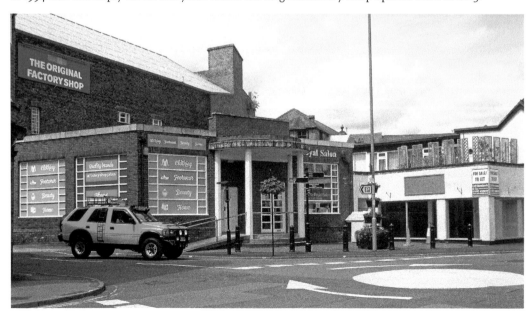

The Bear/Smithfield Hotel

On the left is the Bear Hotel, which was erected at the end of the nineteenth century. In the 1901 census of public houses it was owned by Dorsett Owen & Co., whose brewery was on English Walls. The landlord was Thomas Jones, who kept the premises in good condition and was a good manager. There were three rooms upstairs and three on the ground floor, and stabling for eight horses. By 1905 the landlord was David Jones who became mayor of Oswestry in 1908. He advertised in 1905: 'Dining Room the Bear's Paw Salop Road and English Walls.' The hotel was renamed the Smithfield, housing the Bullring Bar, but closed around 2015. Early in 2017 there were plans to convert the building into seven apartments but it has since reopened as a three star hotel, retaining its former name.

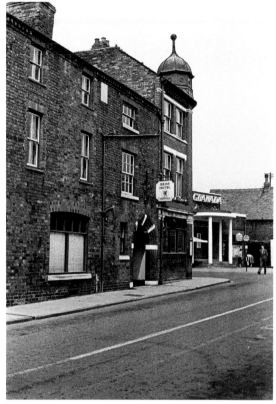

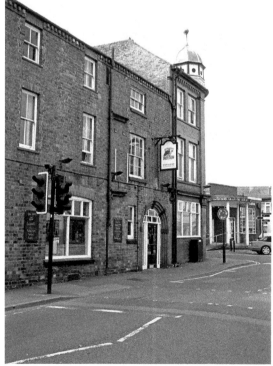

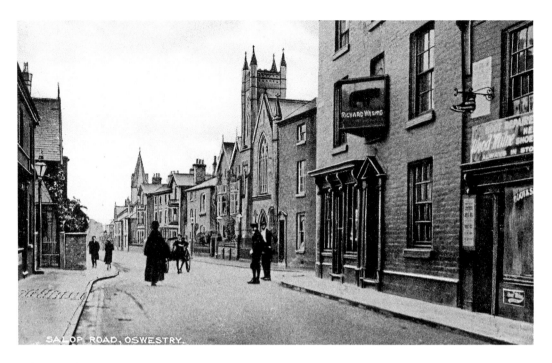

Salop Road

This view is looking down Salop Road towards Victoria Road. On the right is the Bear, or Bear's Paw Inn, which was occupied by Richard Waring. The brick building just beyond has been removed since the old view was taken, revealing part of a timber-framed house that stood behind it and next to the Baptist Chapel. The chapel occupies the site of a timber-framed building that was once the Black Gate School for Girls. After demolition of the site a foundation stone was laid by Mayor A. Wynne Corrie in June 1891, and the completed building was opened for worship in March 1892 at a cost of around £2,750. In 1909, a Sunday school was erected, which opened in September of that year. Traffic in the earlier view was much lighter than today.

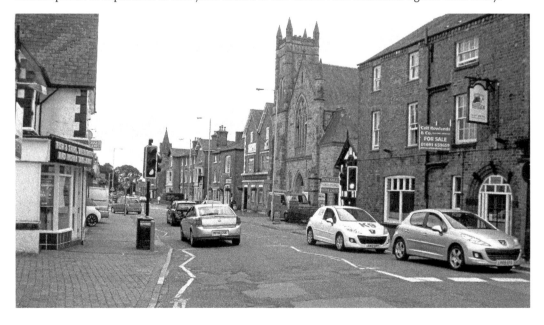

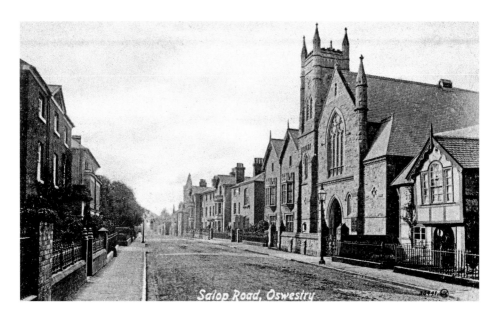

Salop Road, Oswestry

Baptist Chapel and Black Gate

The old view shows a very quiet Salop Road at the beginning of the twentieth century, compared with the new photograph in the early years of the twenty-first century. It also shows the Baptist Chapel, which held services on Sundays at 10.45 a.m. and 6.30 p.m., and on Thursday evenings at 7.30 p.m. Since closure, the chapel has been converted into Body Tech Health Club. On the ground floor is a ladies'-only gym and a separate aerobics studio. Upstairs is a mixed gym, changing rooms and showers. The timber-framed building dates from around 1600, with later additions and alterations. It has an entrance porch with an attractive Venetian window, which was inserted later. It was once a public house called the Smithfield Inn in the mid-nineteenth century. It later became the Black Gate Tea Rooms, providing visitors with morning coffee, lunches and afternoon teas, before becoming the Black Gate Restaurant. It closed for a while before reopening as a restaurant under its old name in August 2017.

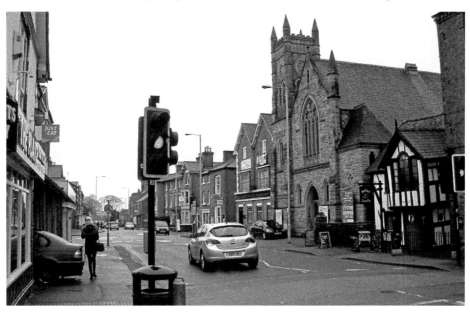

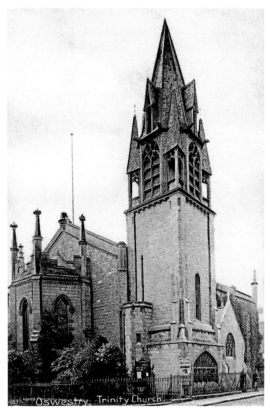

Holy Trinity Church

Holy Trinity Church is situated on the corner of Salop Road and Roft Street. The church was designed by Thomas Penson, an Oswestry architect, and was erected in 1837. It was built to ease the pressure on St Oswald's Church as the population of the town grew, but it did not become a separate parish until December 1842. The new parish was formed out of a section of Oswestry and the townships of Middleton, Hisland, Wootton, Aston and Maesbury. In 1894, a Lady chapel was erected on the south side of the church, and the same year a tower with a wooden spire was built on the north-west corner. In the new photograph a hedge has replaced the railings, the pinnacles have been removed from the chancel and the flagpole has disappeared from the roof.

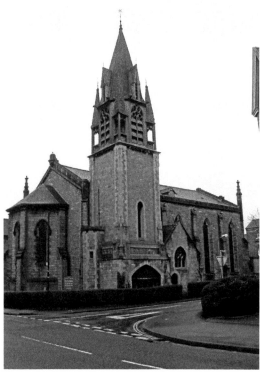

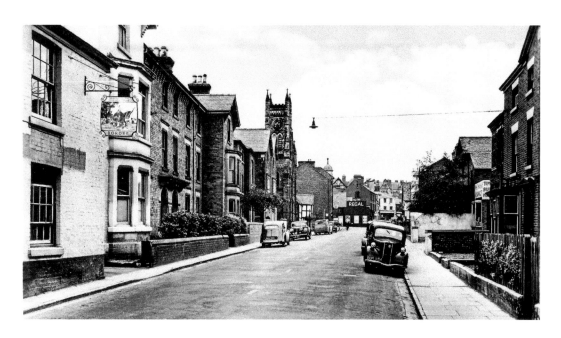

Salop Road

The above view of Salop Road, looking towards Leg Street, can be accurately dated to 1932 as the Regal Cinema is under construction in the distance. The Barley Mow Inn, on the left, was housed in an old building that had been refronted and was at this date selling Border Ales. The inn has been demolished and the land is now used as a road leading to the town's main car park. The building to the right of the inn is Belgrave Place, erected in 1867 by Griffith Morris, a builder, on the site of his home and workshops. His son John, who was mayor of Oswestry in 1870 and 1879, lived there until his death. On the right, most of the buildings above the bay-windowed house are modern. Opposite the chapel is Black Gate Road, which leads into Sainsbury's and through to Oswald Road.

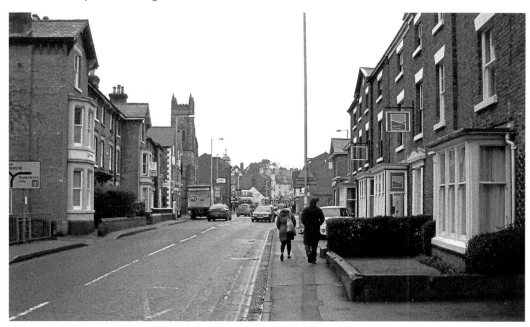

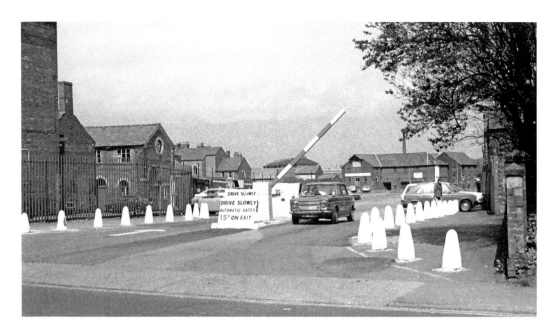

Smithfield Car Park

This is the old entrance and exit to the Smithfield Cattle Market car park on Salop Road. The entrance was made by the demolition of the Barley Mow Inn. The sign advises motorists to drive slowly because of the automatic barriers and that a stay in the park would cost them 15p on exit. The modern photograph shows the entrance has been made narrower and is just for cars entering the park, the exit being on the opposite side at the junction of Smithfield Road and Roft Street. The car park has space for around 500 cars and was opened on 4 May 1970 by Lieutenant-Colonel Heywood-Lonsdale, the Lord Lieutenant of Shropshire. When first opened, motorists had to pay just 5p on exit, but by 1980 it had gone up by 200 per cent.

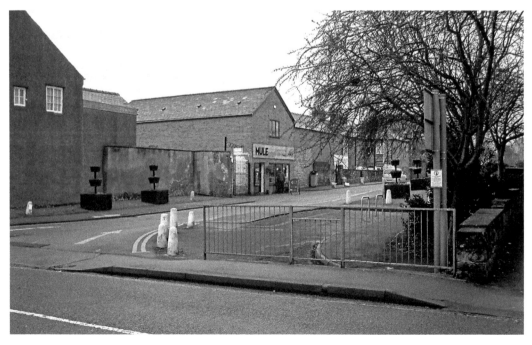

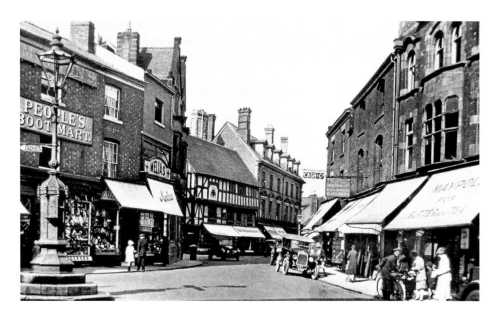

The Cross

The photographer has his back to Church Street and is looking towards The Cross, with Bailey Street to the left and Cross Street ahead. The ornamental gas lamp drinking fountain was made out of cast iron and replaced the old one that was moved to Castle Bank. A memorial plaque on the new one was inscribed 'W. H. G. Weaver, Mayor, 1882'. Behind the fountain is the People's Boot Mart and to the right is Melias' grocery shop. In Llwyd's Mansion on the corner of Bailey Street is the shop belonging to George Dutton & Son, who were listed as 'Family grocers, fruit and provisions merchants and French and Italian warehousemen'. The ladies on the right are standing outside the Maypole – another grocery shop. In the modern view several buildings on both sides of the road have been replaced and the old Cross drinking fountain has been restored close to its original position.

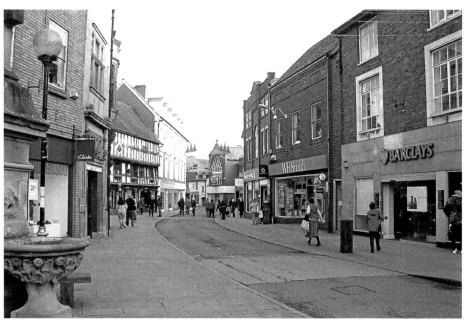

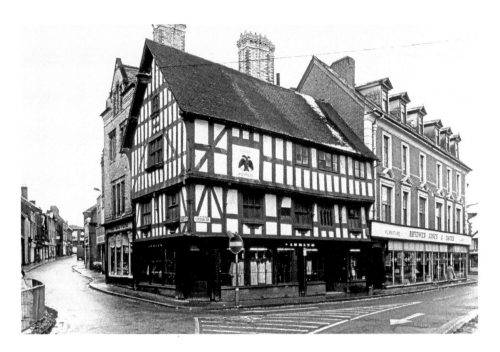

Llwyd's Mansion

Llwyd's Mansion stands on the corner of Cross Street and Bailey Street and once belonged to the Llwyds of Llanforda. Parts of the building dates back to the mid- to late fifteenth century, but it was remodelled around 1604. The emblem on the side of the house is the Austrian two-headed eagle. It commemorates an ancestor of the Llwyd family who regained the Emperor of Austria's standard after it had been captured at the siege of Acre in 1190. The building to the right is Glasgow House, which was occupied by drapers for many years. In the older photo it is occupied by Bradley's Drapery Stores Ltd, who also had another outlet in Church Street. To the left is Bailey Street, looking up towards Bailey Head, which is now pedestrianised.

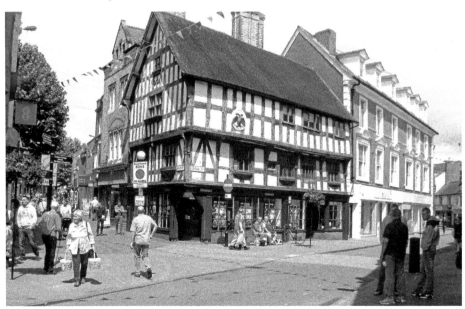

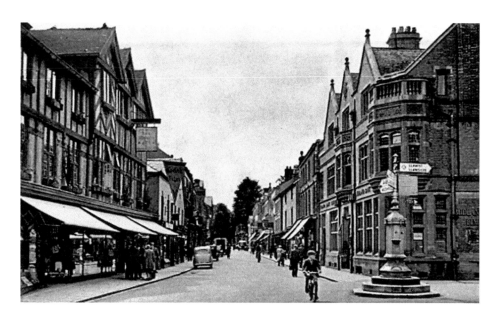

The Cross to Church Street

This view is looking directly towards Church Street from The Cross, with Willow Street on the right. The timber-framed shop on the left was founded by R. & R. Hughes & Co. around 1868. At the beginning of the twentieth century they were listed as 'General Drapers, Ladies' and Children's Outfitters, Gentlemen's Mercers and tailors.' The mock-Tudor frontage was added to the building in 1929. The bank on the corner of Willow Street was built in 1890 for the North & South Wales Bank. They amalgamated with the Midland Bank in 1908, who took control of over 100 of their branches. The bank became part of the HSBC Bank in 1992. The Cross is an area once used as the town's marketplace. A cross and ornamental drinking fountain were erected in the centre of the roads in 1862, but were replaced twenty years later by the one in above image. The ornamental cross and drinking fountain were moved to a park next to the Castle Mound, but has recently been restored to The Cross, as seen in the photo below.

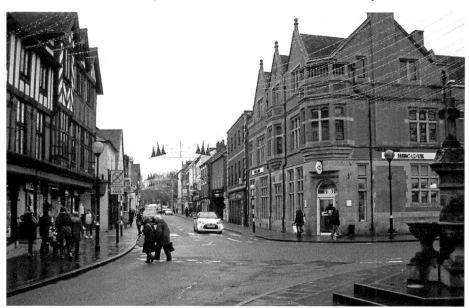

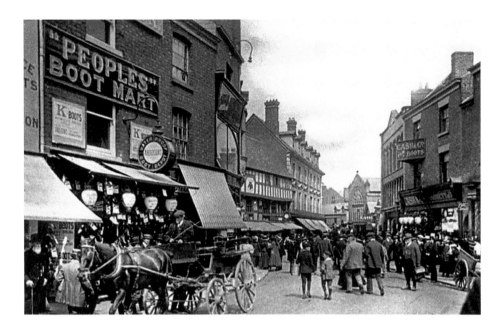

The Cross

The old view looking from The Cross to Cross Street was probably taken on a market day around 1910. On the left, with the four gas lamps outside, is John Anderson's 'Peoples' Boot Mart selling K Boots. To the right is the retail grocery and provisions shop, owned by Francis & Beckitt. Both shops were replaced in the 1980s. Across the road at No. 3 Cross Street is Cash & Co., who were boot and shoe retailers and also had four gas lamps outside their shop to light their wares during the dark winter months. This shop was also demolished in the 1980s and was replaced by a WHSmith store. The tall building at the bottom of Cross Street was once occupied by Aston's furniture store. Cross Street is now pedestrianised, but looking at the old view, you would believe it always had been.

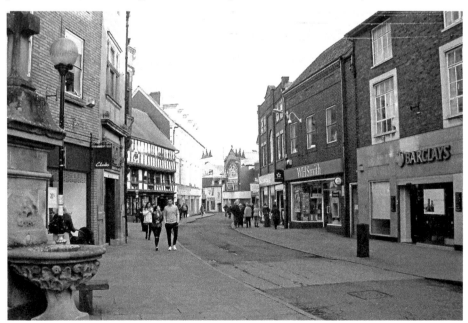

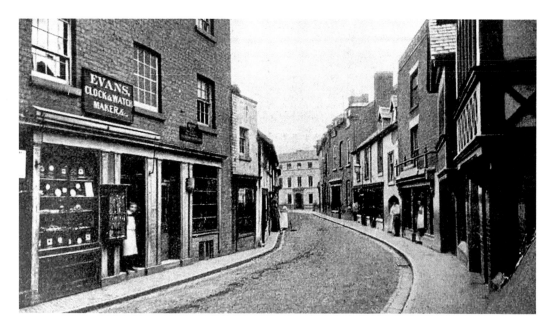

Cross Street

The old photograph shows Cross Street looking towards Leg Street prior to the alterations in the 1880s. Before the reconstruction, the road was very narrow, being just 17 feet wide at one point. The buildings were also very dilapidated and in danger of collapsing. The man standing in the doorway of the shop on the left is presumably Mr George Edward Evans, a jeweller and a clock and watchmaker who occupied the premises from the mid-1860s until the building was demolished. Facing down the street is the Queen's Hotel. In the modern view, the property for sale was built towards the end of the nineteenth century by Robert Lloyd of Glasgow House as their new furniture showroom. It was later taken over by Aston's, who had a similar business in Shrewsbury.

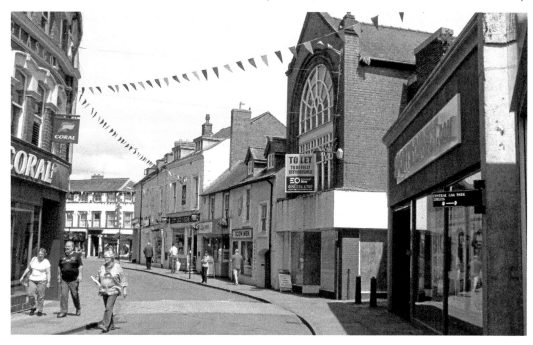

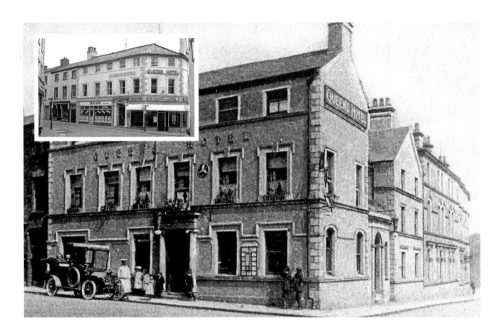

The Queen's Hotel

The Queen's Hotel stood on the corner of Leg Street and Oswald Road. In the eighteenth century it was a small inn belonging to the Aston estate. In the early part of the nineteenth century a coach called *The Nettle*, which ran between Welshpool and Chester, arrived there at 6.30 a.m. on the outward journey and at 6.30 p.m. on the return. Another coach, *The Royal Oak*, ran a daily service to Welshpool and Newtown. The fare to Welshpool was 6s (30p) for an inside seat or 3s 6d (17 ½ p) outside, and 11s (55p) inside or 7s (35p) outside to Newtown. After John Lloyd bought the hotel in 1870 it was considerably enlarged and transformed into a first-class commercial hotel. By 1980 the corner of the building had been taken away, while the ground-floor section to the right of the main entrance had been redeveloped into an Iceland frozen food store. Today, the whole of the ground floor is occupied by Martin Britten's Club House, a clothing retailer.

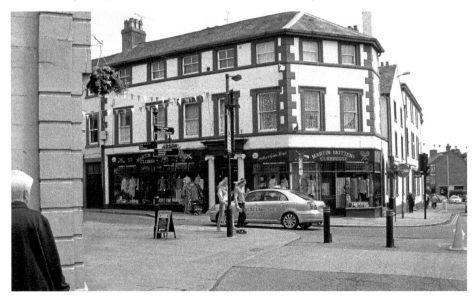

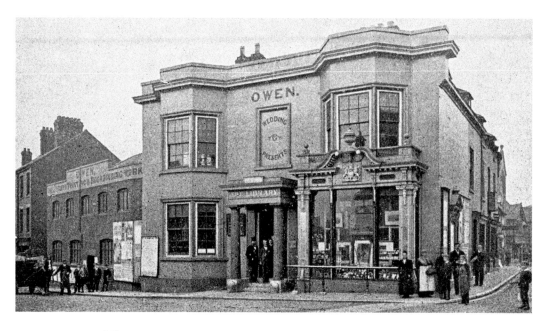

Cross Keys/Library

The building on the corner of Cross Street and Leg Street was once the library, which was run in the mid-nineteenth century by T. Owen & Son. They also sold wedding gifts and printed the monthly *Advertising Circular*. The building had once been part of the Cross Keys, which was the principal coaching house in the town. It became the library towards the end of the 1850s. The building to the left (which was once part of the library) is the same, but the roof has been altered and it has been divided into shops. In the 1960s the main building was occupied by WHSmith & Son, but is now the Red Cross charity shop. The frontage has greatly altered, with the loss of the grand entrance at ground-floor level, a bay window on the upper floor and a top section of wall that hid the roofline. The entrance to the pedestrianised zone is blocked by bollards, but emergency vehicles are able to gain access.

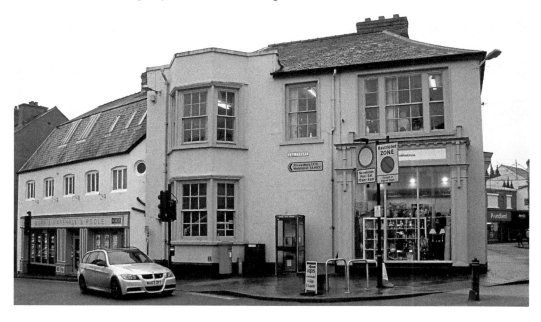

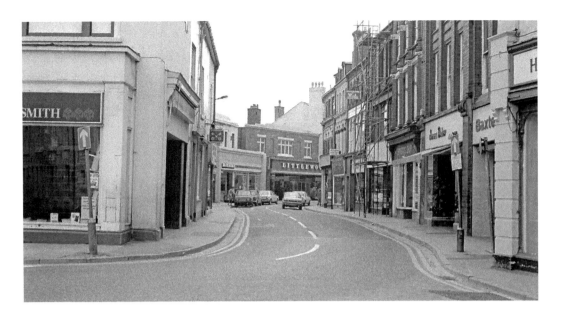

Cross Street

This is a view of Cross Street looking towards The Cross. On the left is the sign of the Cross Keys Hotel that was mentioned in a parish register in 1693. The hotel once had a grand entrance on Leg Street where Smith's shop is situated, but was reduced in size around 1860. In the first half of the nineteenth century it was a major coaching inn on the London to Holyhead Road, with coaches such as *The Express*, *The Pilot*, *The Menai* and *The Royal Mail* taking passengers to all parts of the country. Littlewoods can be seen on the corner of Cross Street, which opened on 1 November 1950. At one time it stood next to the Woolworth's store that by 1980 had moved to Willow Street. The site was then occupied by a Wilkinson's store, which today is occupied by Sports Direct and Littlewoods is occupied by Poundland.

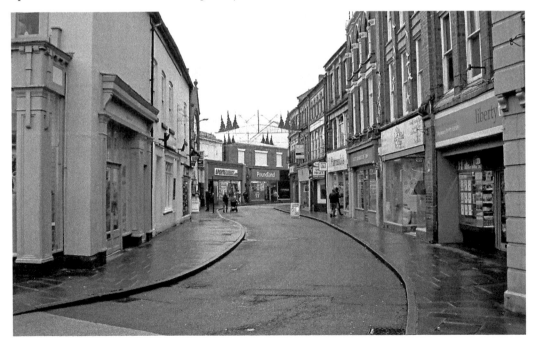

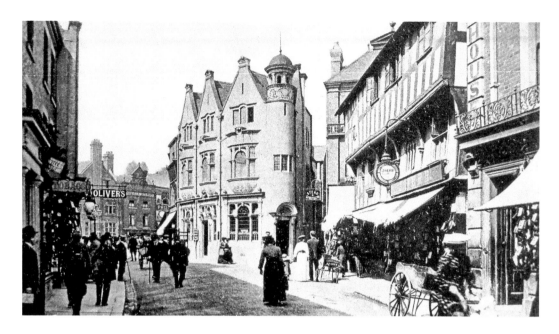

Cross Street to The Cross

The photographer is looking back towards The Cross from Cross Street, with Llwyd's Mansion on the right. In the old view the mansion is divided into two shops: Jacob Herr, a shoemaker, nearest the camera, and Dutton's grocery shop next door. Further along is the sign for Stead & Simpson, who sold boots and shoes, and across the street is the sign for another shoe shop belonging to George Oliver. The impressive building in the centre was built for the National Provincial Bank. It was later occupied by the Abbey National Building Society and is now used by the Santander Bank. Just to the right of the building is a narrow alley linking The Cross to Willow Street, which is known by the Welsh name Clawdd Du – 'the Black Ditch'.

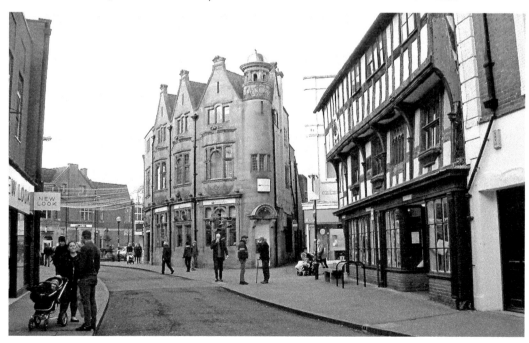

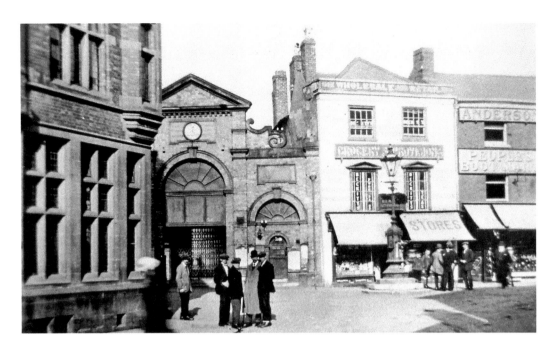

The Cross Market

The old photograph of The Cross was taken around 1905. The photographer has his back to Church Street, with Willow Street to the left and Cross Street to the right. The building with the clock and the rounded windows is the Cross Market, which was built in 1842, enlarged in 1880 and 1900, and extensively remodelled in 1903 at a cost of £6,000. The clock was placed over the main entrance in 1854. It was the idea of Charles Sabine, a local solicitor who organised a public subscription to pay for it. A legend in Latin was inscribed on both sides of the clock, which loosely translated reads, 'Time and Money, Space and Weight, by one fixed standard calculate.' Today, the ground floor has been redeveloped into a shop, and the buildings to the right – housing the grocery store and boot shop – have been modernised and rebuilt. The original cross and drinking fountain have been brought back, but placed in a slightly different position to allow traffic easier access into Willow Street.

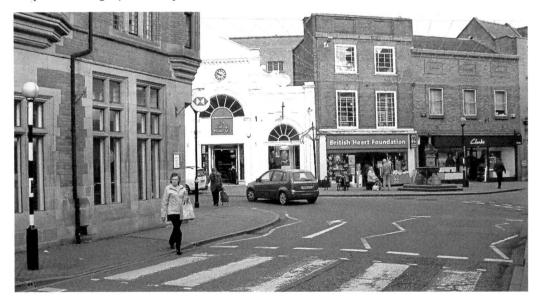

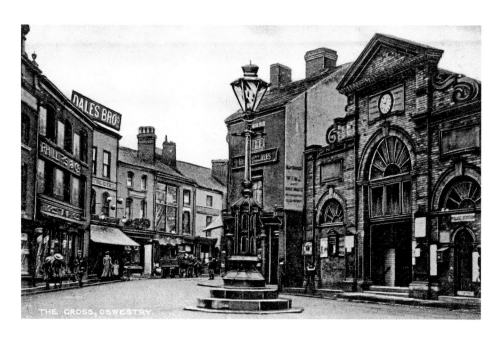

THE CROSS, OSWESTRY.

The Cross to Willow Street

This view from The Cross to Willow Street was taken around 1910; the substitute drinking fountain and ornate gas lamp can be seen in the middle of the road. On the right is the frontage and main entrance into the Cross Market. Phillips's Store Ltd, on the left, was one of the firm's many outlets around the county. They were grocers and tea blenders who traded in the town through to the middle of the twentieth century. To the right are Dale Bros, who occupied that site for many years. They sold a wide variety of goods and household furnishings and were once pawnbrokers – note the sign outside their shop on the old view. The building next door is the Bull's Head, which became an inn around 1866. The Phillips's store site was replaced in the 1960s and was occupied by the Britannia Building Society. The market entrance is now occupied by the Edinburgh Wool shop, which moved there in July 1996; before that the shop housed Wilson's Fashion Centre, who sold ladies' clothing. The bank building has also been extended into Willow Street.

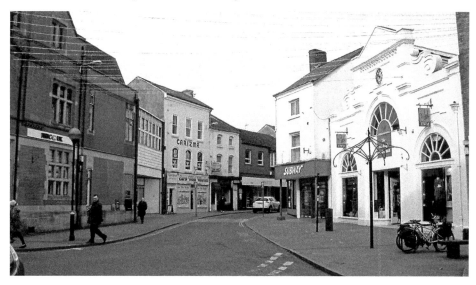

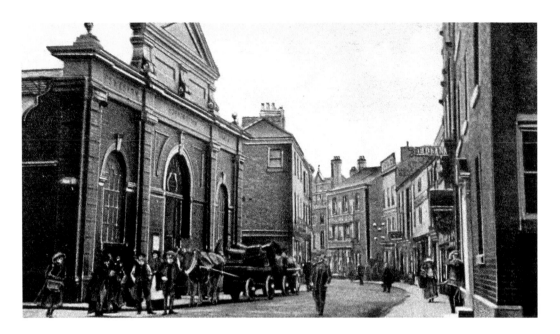

The Cross Market Willow Street

This view of Willow Street is looking back towards The Cross, with Phillips's and Dale Bros stores on the bend. The Boar's Head Inn, on the right, was housed in a small timber-framed house with dormer windows until the 1870s, when it was completely rebuilt and modernised. On the left is the Willow Street entrance to the Cross Market. The original market opened in 1842. It was erected by Griffith Morris & Sons and built out of red brick with a Cefn stone dressing. It was paid for by private subscription and partly by a charge upon the rates. The lady on the left is coming out of New Street, which was created at the beginning of the twentieth century when alterations were being made to the market. The market was knocked down in the 1960s and a new Woolworths store was built on the site, but further back from the road. The building now houses a Home Bargains store. The house just beyond is still the same, apart from a modern window on the ground floor.

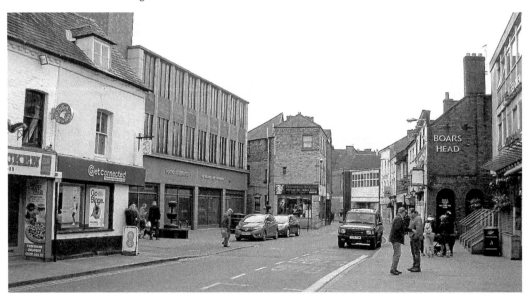

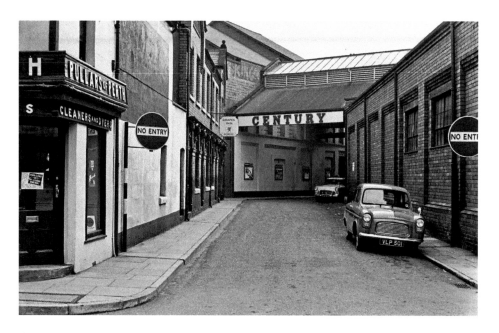

New Street

This is New Street looking towards the Century Cinema, with the Cross Market on the right and the Grapes Inn on the left. The cinema opened as the King's Hall in 1914, which had a seating capacity of 700. It was altered twice in 1933 and 1955, when it changed its name to the Century. On 4 January 1966 the cinema was closed and altered into the Granada Bingo Club. Bingo continued there until 1998, when it was converted into a Wilkinson hardware store that opened the following year. The first Grapes Inn was mentioned in 1688. It originally fronted Willow Street, but was moved to this site when the old building was demolished at the beginning of the twentieth century for an extension of the market hall and to form part of New Street. In 1960, the shop on the corner was occupied by Pullars of Perth, who were dry cleaners and then by the Red Cross charity shop. It is now Get Connected, who trade in mobile phones.

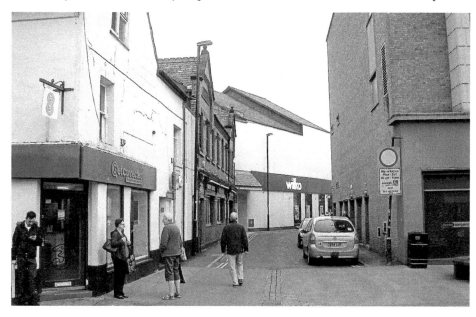

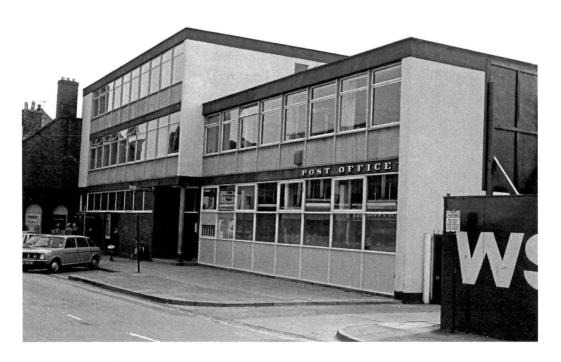

Oswestry Post Office

The first view shows Oswestry post office in Willow Street in 1980. A post office was opened at No. 17 Willow Street in 1839, just a year before the 'Penny Post' was started. It moved to Church Street in 1879 but returned to No. 17 Willow Street when these new premises were built by local building firm W. Watkins & Co. Ltd, opening on 30 August 1962. After the Royal Mail sorting office moved to a nearby industrial estate, the left-hand side of the building was converted into a Wetherspoon's inn and restaurant, which opened in April 2003. The inn was named after Wilfred Owen, the famous First World War poet who was born in Oswestry in 1893 and was killed in action just a week before Armistice Day in November 1918. Since the 1980s photo, the car bay has been replaced by a bus stop and there are now steps leading into the inn.

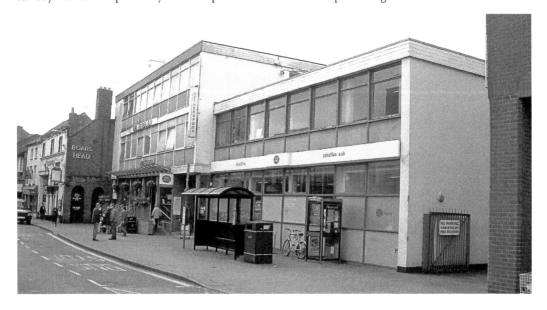

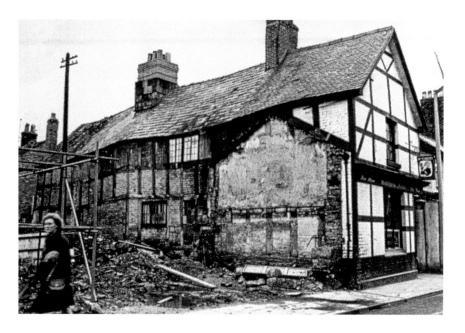

The Butchers' Arms

The Butchers' Arms in Willow Street is a Grade II-listed building, with parts dating back to the sixteenth century. The older photograph shows how tastes change: when timber went out of fashion, they placed brick cladding on the front; when timber framing came back into fashion, instead of uncovering the original beams, they painted the framework onto the brick. In 1691, a room in the building was used as a meeting place of the Independent Church, a forerunner of Christ Church United Reform Church. The Butchers' Arms has been an inn since the eighteenth century and for many years brewed its own beer, but by the 1960s they were tied to Younger's Brewery. The opening to the right is known as Butchers' Arms Shut and leads into Arthur Street. The first photograph was taken in December 1964 and shows that the buildings to the left of the inn have been demolished. In the modern view, the timbers have been restored and more windows inserted on the first floor, but the ground-floor window advertising home-brewed ales has been replaced.

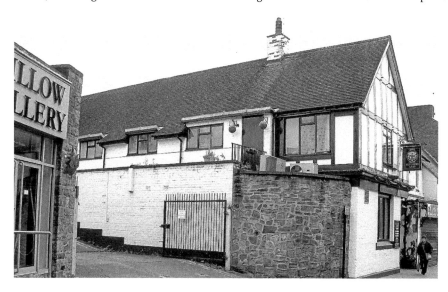

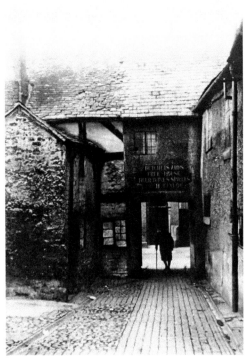

Butchers' Arms Shut, Arthur Street

This is Arthur Street looking towards Willow Street. The old photo dates from the latter part of the nineteenth century. The name was first used from the eighteenth century and the street has also been called Stryd Arthur, in the Welsh manner. Due to the close proximity of the inn at the Willow Street end, it was known as Butchers' Arms Shut. The street leads from Willow Street to the Bailey Head and was once described as 'ill paved, unsavoury, dark and dirty'. In the modern view the cobbles and brick walk have been replaced by tarmac, a side entrance has been inserted into the inn, the timbers have been opened up, the building to the left has been rebuilt and a Sky Sports sign has replaced the old one advertising 'Beer, Wines & Spirits'. Opposite, in Willow Street, the door with the rounded light is still there.

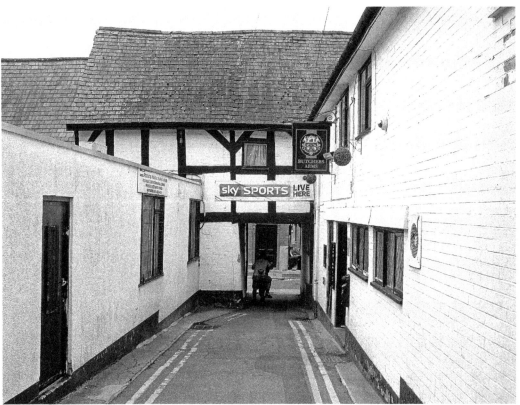

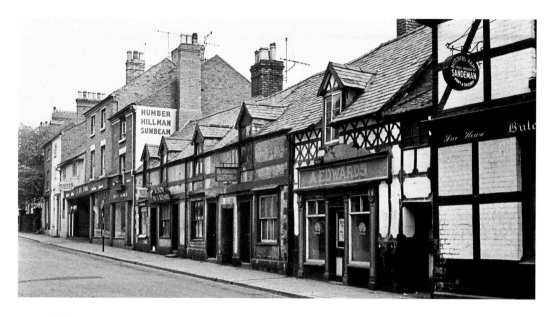

Willow Street

These cottages stood just to the left of the Butchers' Arms in Willow Street and were demolished soon after this photograph was taken. The inn was also under threat, but thankfully survived. The cottages were timber-framed, but the frontages had been covered with plaster. The first shop after the inn had timber framing painted over the front as the fashions changed. Three businesses occupied the cottages: A. Edwards, a baker, was in the first; in the middle was Samuel Martin, a fruiterer and greengrocer; and at the top was Mr Lloyd, who was a shoe and boot repairer. The buildings at the top were not demolished and in the earlier view show that a garage with two petrol pumps and selling Humber, Hillman and Sunbeam cars occupied most of them. In the 1930s the business was run by George Maddox, but was later taken over by Roy Evans, who was a Rootes dealer. The cottages have been replaced by a single-storey building housing the Willow Gallery, which sells artwork and hosts exhibitions, workshops, live music events and craft fairs.

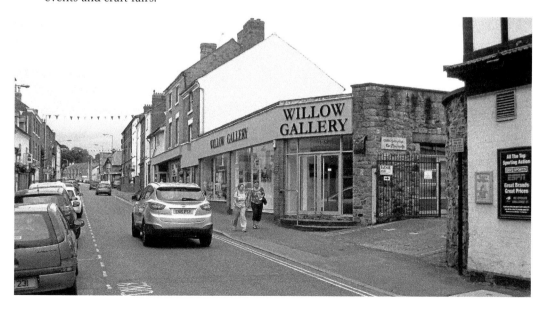

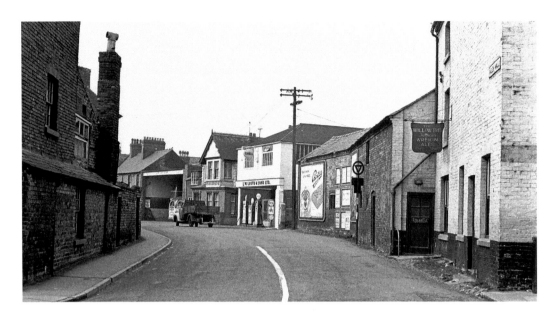

Welsh Walls

This view is looking down Welsh Walls from Willow Street, towards the old Cottage Hospital (built in 1870) and the National School – both now closed. The garage in the centre of the old photograph belonged to John Lloyd, who founded the business in the 1920s. By the 1960s they were agents for Renault cars and also part of Lloyd Bros Travel Agency Ltd, who were based in Arthur Street. They were members of Abta and advertised that they were 'Booking agents for the World's principal transport and holiday organizations'. The old buildings have been demolished and the site is now used by E. M. Hughes Autocentre. The building on the right-hand corner is the Willow Tree Inn, who sold Wrekin Ales. The inn, formally known as the White Lion, has closed and the ground floor has been converted into offices. The building on the other corner has also been altered and the large chimney stack has been removed.

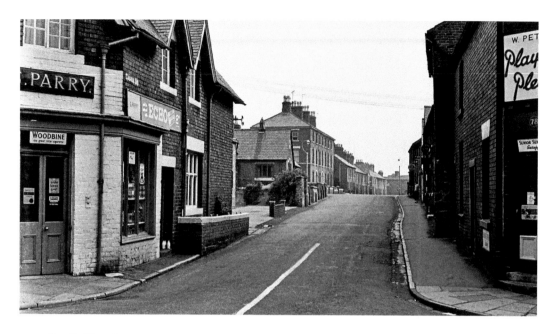

Castle Street

Almost opposite Welsh Walls is Castle Street, which loops around the Castle Mound to come out at the junction of Beatrice Street and King Street. On either corner are two grocery shops, both advertising cigarettes. Parry's, on the left, is also advertising Echo Margarine, costing 8*d* (3 ½ p) for half a pound. The single-storey building on the left was an infants' school, which was built in 1873 and enlarged in 1889 to accommodate 123 children. It was known as the Ragged School, a name used all over the country in Victorian times for charity schools set up for the free education of poor children in the area. The site is now used as a Co-op store. The three-storey building above is just beyond Oak Street. The buildings on the right have been removed to expose the Oswestry Methodist Church, which was built on the site of the Ebenezer Chapel and School Room. The foundation stone was laid on 16 June 1898 and the first service was held on 21 March 1899.

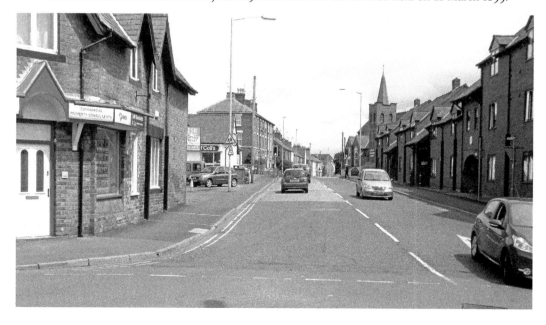

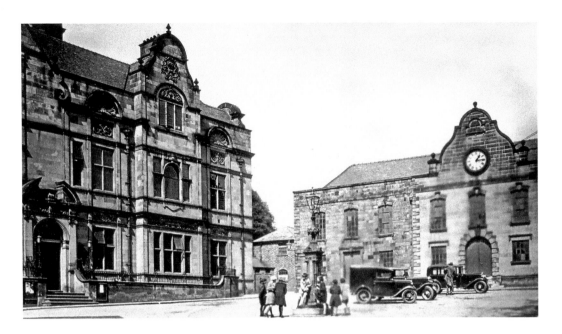

The Bailey Head

Bailey Head was once part of the outer defences of the castle, the mound of which stands behind the Guildhall on the left. It has been the town's marketplace for several hundred years, and market stallholders still regularly trade there on Wednesdays and Saturdays. The area is also used today for a number of other events, which include cultural events, a food and drink festival, and several specialist markets that feature youth, artisans and produce from the Continent. The building on the right is Powis Hall, which used to be the Guildhall until around 1839, when it was redeveloped into an indoor market. The old building was demolished and replaced in 1963 by a structure that at the time won great praise for its architecture. A plaque on the building states, 'Oswestry,-Powis Hall. Reconstructed by the Corporation of Oswestry and opened 11-9-1963, by Col. The Right Hon. The Earl of Powis CBE TD DL, whose predecessor gave the original building in 1839.' The water pump in the centre of the old view was sunk in 1776 at a cost of 5 guineas. It was removed in 1958.

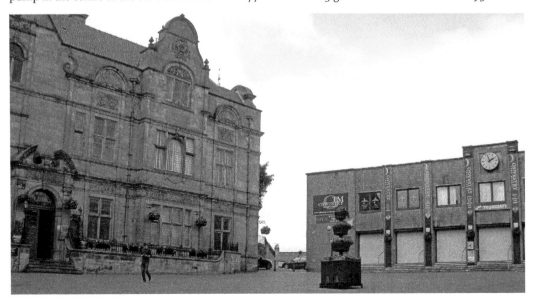

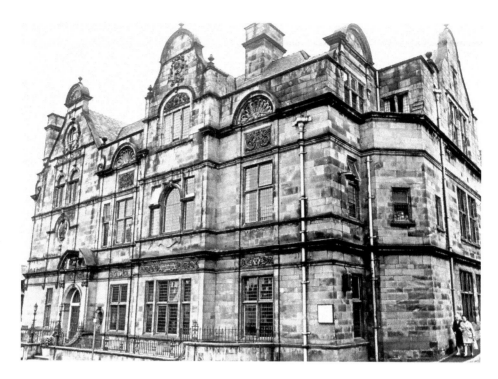

The Guildhall

The first Guildhall was erected on this site in 1782 in place of the Wool Hall. This building was designed by Harry A. Cheers of Twickenham in a Renaissance style and built by W. Thomas of Oswestry for around £11,000. It was opened in November 1893 and in January the following year a new free library was opened there by William Walsham How, who had been rural dean of Oswestry before becoming bishop of Wakefield. By the 1990s the building needed renovating and, after securing Heritage Lottery Funding, a complete overhaul was carried out, which included a new roof and the removal of dry rot. The refurbished building was reopened by Algernon Heber Percy, Lord Lieutenant of Shropshire, in April 2000. After the county court was taken out of the building, it was replaced by a new museum that opened in 2012.

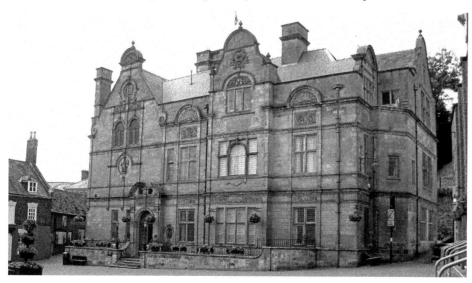

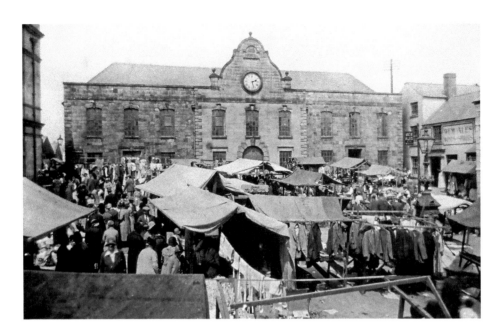

Powis Hall

Powis Hall, on the Bailey Head, was built in the Georgian style in 1839. Bagshaw's 1851 Directory of Shropshire describes it in this way: 'The Powis Market Hall forms one side of a spacious area of the Bailey Square and is a plain stone building with a high clock tower. The front part of the structure was formally used as the Guildhall, at the back additional erections have been made in brick–here the corn market is held on Wednesdays and is numerously attended by the farmers in the surrounding district.' By 1909 the old clock tower had to be rebuilt as the weight had caused structural faults below. The old tower was once crowned by a weathervane depicting a golden dragon. It was replaced with the modern building in 1963. There are two inns in the top right-hand corner. The top one, selling Wem Ales, is the Red Lion, while immediately to the right is the Eagles Inn, which until around 1869 was called the Castle Tavern and is now known as the Bailey Head.

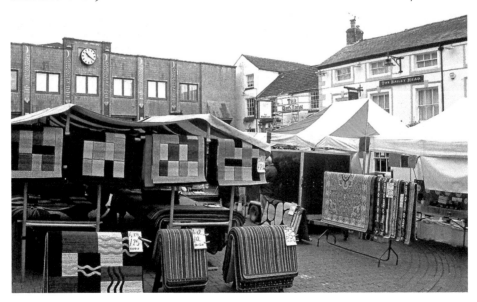

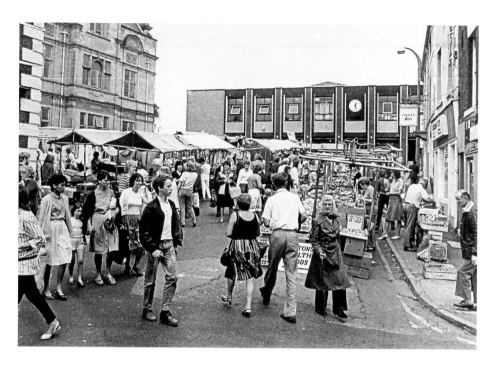

Oswestry Market

The Bailey Head has been the site of an open-air market for several centuries and is right in the centre of town. The old photograph was taken on 10 July 1983, when a guide from around that time reports: 'Recent years have also brought a steady growth in the Wednesday open and covered markets on the Bailey Head and old Horsemarket. Traders there selling almost every conceivable line in household requirements acclaim Oswestry as the best market north of the Trent.' This vibrant market is still held every Wednesday and Saturday, along with the indoor market held in the Powis Hall at the top. Farmers' and artisans' markets are also held there on the last Friday of the month.

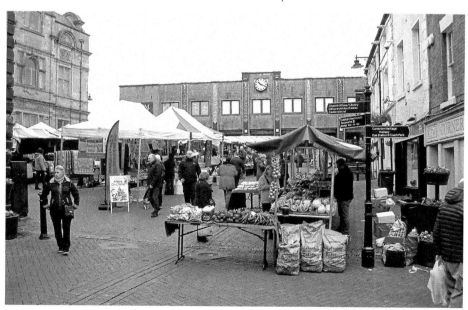

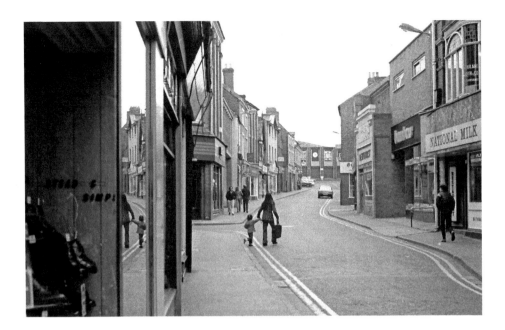

Bailey Street

This is a view of Bailey Street looking up towards Bailey Head. The first was taken in 1980, when you could still drive up towards the Bailey Head and Powis Hall, which you can see in the distance. The hall is now obscured by trees and the road is nicely paved and pedestrianised, getting rid of the unsightly double-yellow lines and creating a more relaxed atmosphere. On the right is the National Milk Bar, which is now occupied by the Halifax Building Society. Just above is Shoe Zone, which also occupies the building above that was Dewhurst's butcher's shop in the 1980s view. For many years Shoe Zone was occupied by Irwin's grocery store, and then Tesco.

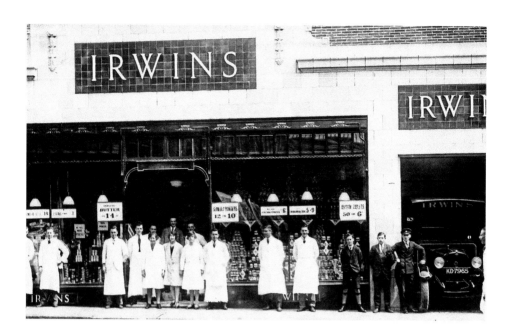

Irwins, Bailey Street

This is a photo of John Irwin & Sons staff outside their grocery and provisions shop at No. 8 Bailey Street. The shop opened towards the end of the 1920s and continued until the 1960s, when it was taken over by Tesco, who were opening branches all over the country. The old photograph was taken in the 1930s, when Danish butter was 1s 4d (approximately 7p) per pound, and you could buy twelve Seidlitz powders (a good laxative and digestion regulator) for 10d (roughly 4p), Bee Vee custard powder 6½d (approximately 3p), a jar of marmalade for 5d or 9d (around 2½p or 3½p) and fifty Aspirin tablets for 6d (2½p). To the right is their delivery van, along with the smart driver in uniform and cap. The site has been rebuilt and is now occupied by Shoe Zone. Note the busker on the right, entertaining the shoppers on their way to and from Wednesday's open market on the Bailey Head.

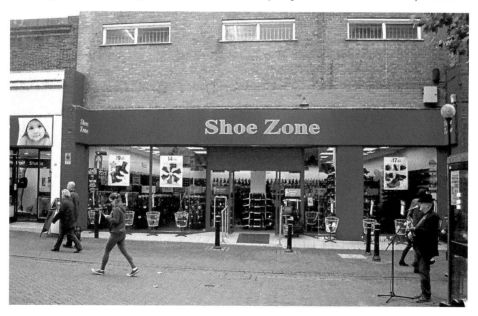

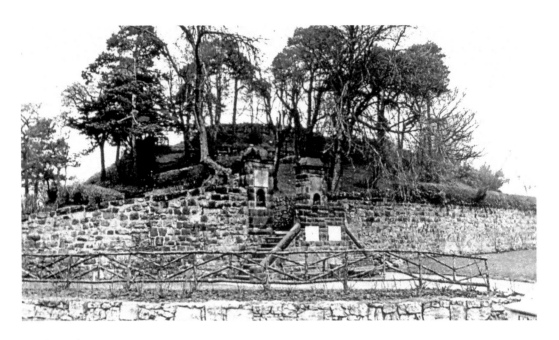

Castle Bank

Very little has changed between these two photos of Castle Bank – taken around fifty years apart. Oswestry is not mentioned in the Domesday Book, although the castle is listed as Castle Luvre. It was thought that the mound was man-made, until the nineteenth century when an archaeological dig found it to be glacial debris that had been shaped into a motte by man. The castle expanded and was well maintained until the Civil War, when the Royalists were forced to surrender and it was later destroyed by the Parliamentarians. The mound was left to decay until 1887, the year of Queen Victoria's Golden Jubilee, when it was decided to convert Castle Bank into an arboretum. The grounds were opened to the public on 24 June 1890 by Mayor A. Wynne Corrie and W. H. Lacon, who was mayor in the year of the Jubilee. The pillars to the entrance of Castle Bank were moved there from the site of Beatrice Gate.

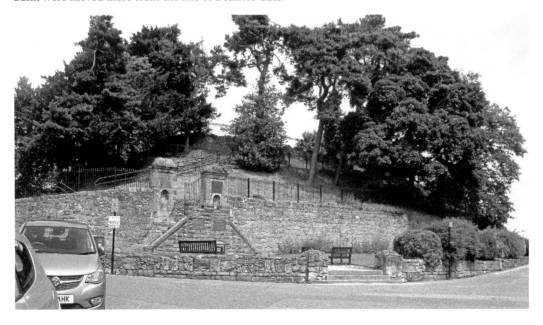

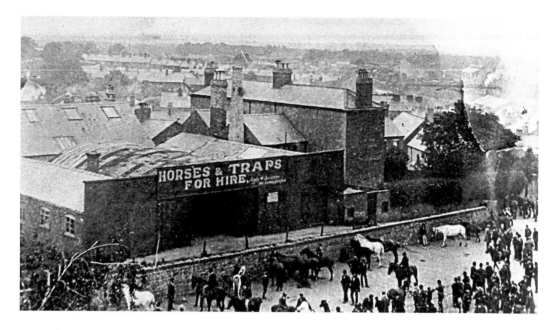

The Horse Market

Oswestry Horse Market is situated below the Castle Bank. It was opened on 4 July 1849, with the extensive ground costing £279. *Eddowes's Journal* announced that at the horse fair on Wednesday 6 April 1859 at 3 p.m., Mr Jenkins of Ellesmere would be auctioning 'the noted waggon stallion, Bold Will, the property of Mr E. Edwards, of Cainileg Issa Lansillin; two splendid Colts by Black Conqueror and Farmers' Glory and several useful Waggon Horses, & c.' In 1894, the January horse sale was held on the 3rd, and it was reported that 'there was a very small show of horses on offer, and these did not realize large prices'. In 1861, a wall was erected around the market. Today, the large buildings have been replaced by housing and the market area is now used as a car park.

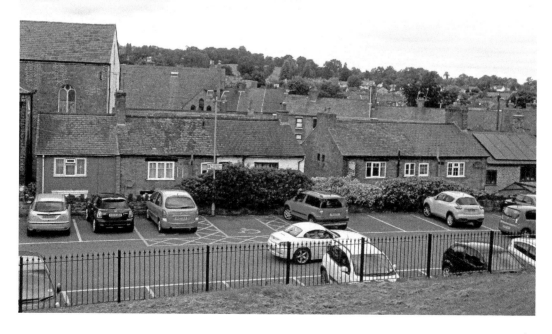

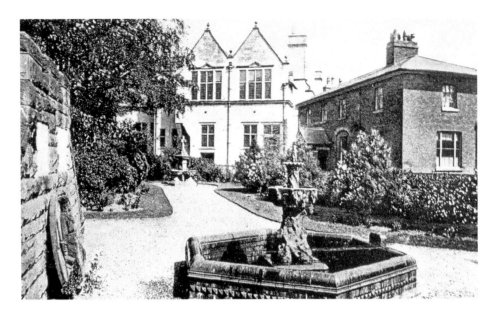

Rear of the Guildhall

To the side of the Castle Bank, at the rear of the Guildhall, is a smaller section of the park that was also completed in 1890 to celebrate Queen Victoria's Golden Jubilee. It was set out with pathways and shrubs. In the foreground is an ornamental fountain, a gift from the Sweeney Brick & Tile Co. To the rear is the ornamental drinking fountain that was situated at The Cross in 1862, and moved to this position in 1882. It was designed by a Mr Wiggington of London. There were three inscriptions on the sides, the first gave the date of erection, the second read: 'The fear of the Lord is the fountain of life.' The third read, 'Presented by Henry Bertie Watkin William Wynn.' It has recently been returned to The Cross, near to its original position.

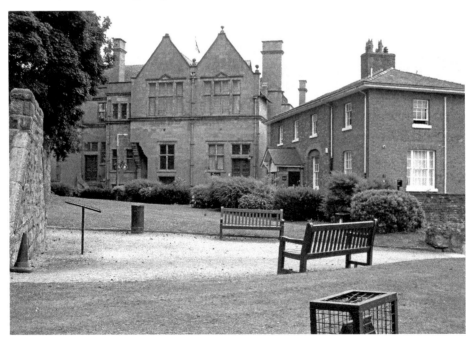

Christic Church

This view, from the rear of the Guildhall, is looking towards Arthur Street on the left and Chapel Street on the right. At the junction of the road is Christ Church, which was built for the Congregationalists. The foundation stone was laid on 7 September 1872 and it was opened for services in 1873. It was designed by local architect W. H. Spaull and built out of Cefn stone at a cost of around £5,200. The impressive west end has a large five-light window, while at floor level are five blind arches – two pierced by doors and three by small quatrefoil windows. The tower on the north-west is topped by a small spire that is 120 feet high. When the Presbyterian and Congregational Churches united in 1972, it became a United Reform Church. Note the gardener in the old view, planting the bowls of The Cross drinking fountain with flowers. Both The Cross and the ornamental fountain have been removed and the area is now grassed over.

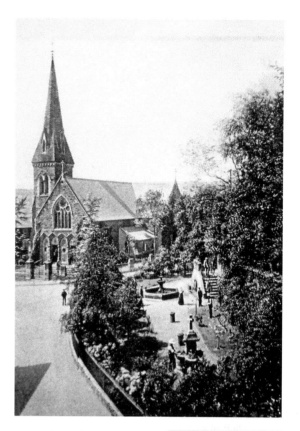

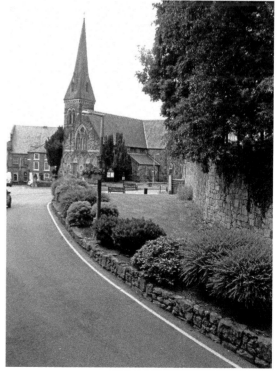

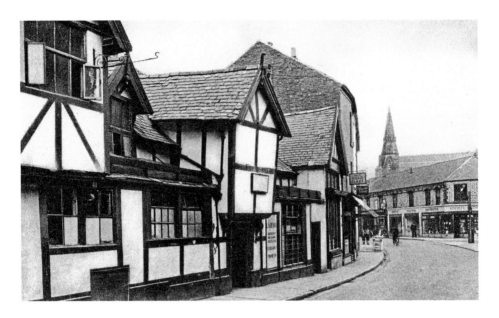

Beatrice Street

This view of Beatrice Street is looking towards Albert Place on the right. The building on the corner of Albert Place was the premises of Oswestry Industrial Co-operative Society Ltd, who were trading there from 1885. By 1930 they had constructed another premises on the other side of the road and had outlets in King Street, York Street and Upper Church Street. Above the Co-op is the spire of the Methodist Church at the junction of Beatrice Street and King Street. It was another building designed by W. H. Spaull in the Gothic style and erected in 1871 at a cost of £2,500. It was demolished in 1964. On the left is the Fighting Cocks Inn, which is next door to the bootmaker Edward George; just beyond, with the adverts for Gold Flake and Player's Cigarettes hanging outside, is the grocery shop belonging to Elizabeth Garner. The inn has been reroofed and the centre part looks more upright than in the old photograph.

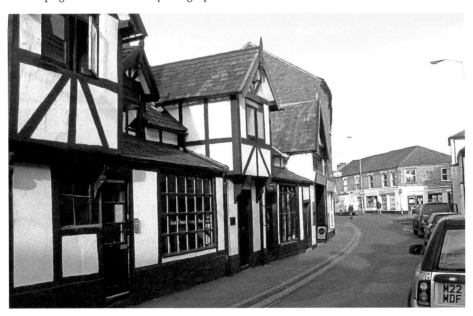

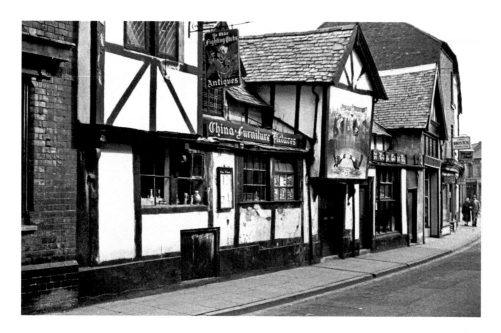

The Fighting Cocks Inn

The Fighting Cocks Inn, with its magnificent sign over the front door, was erected in the late sixteenth century. Records of the inn date back to the seventeenth century, when it was known as the Lower White Horse Inn. In 1727, it was owned by a mercer who was living in Cross Street, and during his time the name was changed to the Fighting Cocks. The house remained an inn until the 1960s, when it was closed and split into shops. One half was an antique shop advertising china, furniture and pictures of days gone by. There was also a coffee bar there, with a jukebox that was run by Roy Hookey. It once housed a shop selling cane furniture, a salon called Scizzor Sisters and a children's shoe shop called Little Soles. It is now occupied by the Brow & Blowdry Bar and TJ's Print & Gift Shop.

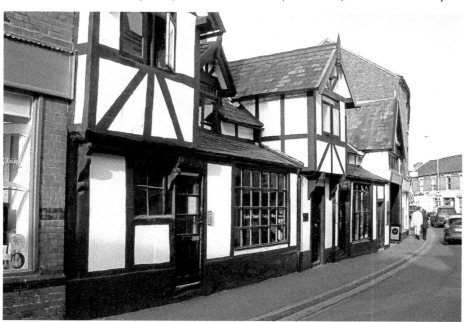

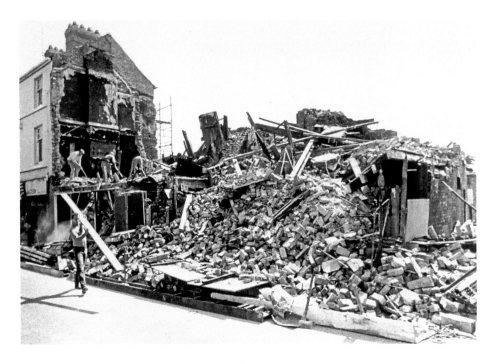

The Corner of Beatrice Street and Madog Place

On 11 June 1989, a devastating fire destroyed the Civic Antique Shop in Beatrice Street and Books Galore around the corner in Madog Place. The building that was erected in 1878 was so badly damaged that it was demolished in July 1989 and the site redeveloped into dwellings. The two men working with picks on the first floor look in quite a precarious position, which probably would not suit modern health and safety rules. Madoc, or Madog, Place is named after Madog ap Maredudd, a former prince of Powys. The buildings are opposite the Fighting Cocks.

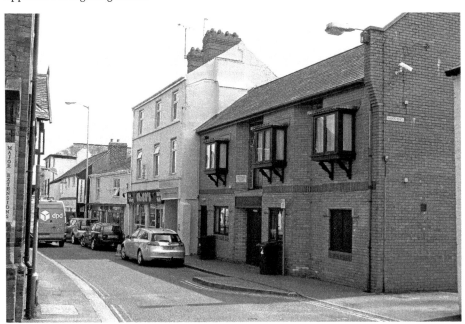

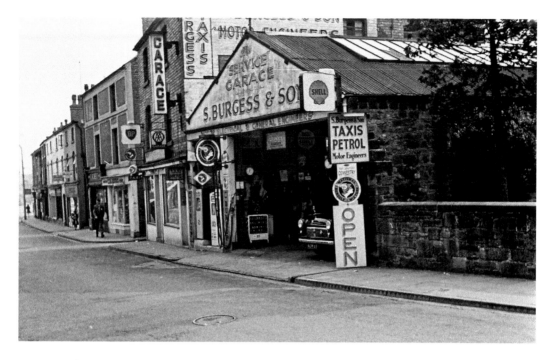

Beatrice Street

This view of Beatrice Street is just below King Street, looking towards the Cambrian Works. The low wall on the right belonged to the Methodist Church on the corner of King Street, which was demolished in 1964. Samuel Burgess & Son opened this garage just after the First World War, when they were listed as 'Electrical and Mechanical Motor Engineers'. They also ran a taxi service, hired out cars and sold petrol from kerbside pumps. They were still trading there in 1967, but by 1972 the garage side of the business had closed and Burgess's Radio Controlled Taxis were operating from King Street. The old buildings have been swept away and replaced by a Morrisons petrol station and a wider entrance into Orchard Street, just below.

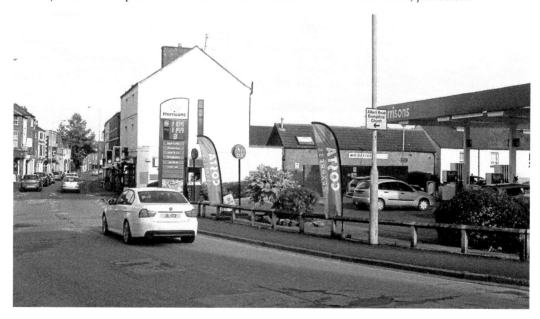

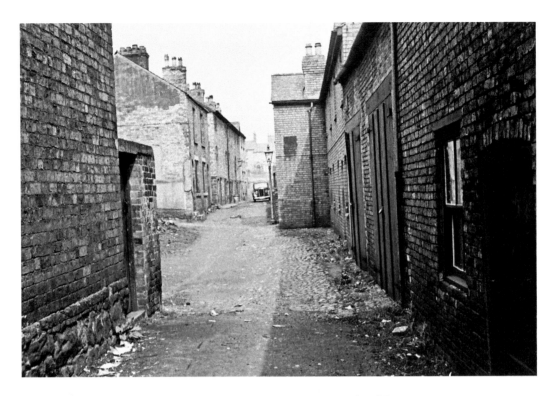

Orchard Street

Orchard Street is a very narrow road that leads through to Eden Street and King Street. It was once full of modest cottages and was built around 1866 to house an influx of families moving into the town to work at the Cambrian Works and on the railway. The cottages were built close together and access was difficult. The buildings on the right were demolished in the 1960s and a section of the Morrisons petrol station now occupies part of the site. A number of cottages on the left and further down the street have been kept and modernised. The old cobble stones and gas lamp have been replaced by tarmac and electric.

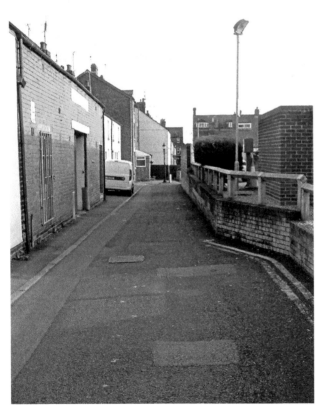

The Plaza, Oswald Road

The Plaza in Oswald Road was another building designed by local architect W. H. Spaull in the Italianate style. It was erected as the Public Hall by the Oswestry Public Hall Co. Ltd and opened in April 1864. It became a cinema in 1909, and by 1914 was known as the Picturedrome. Between 1917 and 1929 it was converted into a music hall called the Playhouse, before reverting back to a cinema. It was renamed the Plaza Cinema in the 1930s, but was closed in the early years of the Second World War when it became a dance hall called the Plaza Ballroom. At one time the frontage was painted pink, and it remained a dance hall until its closure in the 1970s. The demolition photograph was taken in January 1975, when work was halted due to the remaining part being unsafe. K. C. Jones' garage and car sales now occupy the site.

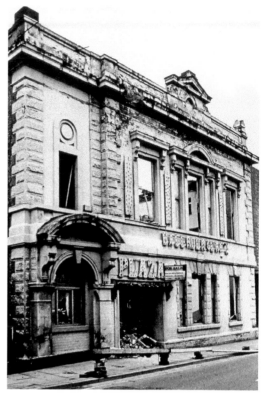

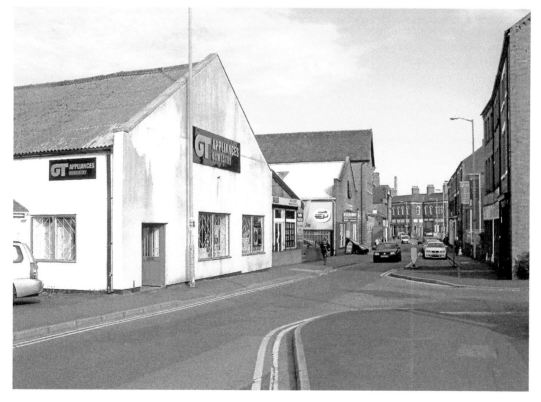

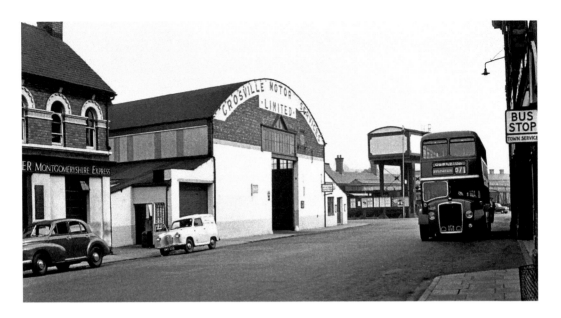

Crossville Bus Depot

The building on the left is the drill hall, which became the bus depot in 1933. The building had a Belfast truss roof – usually used in the construction of aircraft hangers. It was ideal as it created a wide span and plenty of height for a building originally erected as a roller-skating rink. After it was removed, Aldi used the site for a supermarket and car park. The double-decker bus is standing in front of the Cambrian station, and behind the bus is a water tower in the Great Western Railway station on the corner of Station Road. The double-decker bus belonged to the Crosville Motor Co., which was formed in Chester by George Crosland Taylor and his French partner George de Ville in 1906 to build motor cars. The bus would have been painted in the company's livery of green and white. To the left of the garage are the offices and printing works of the *Border Counties Advertizer*, *Wrexham Leader* and *Montgomeryshire Times* newspapers.

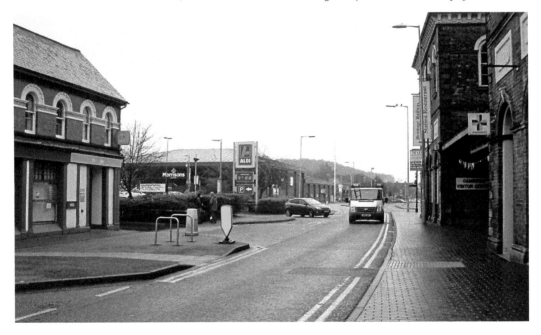

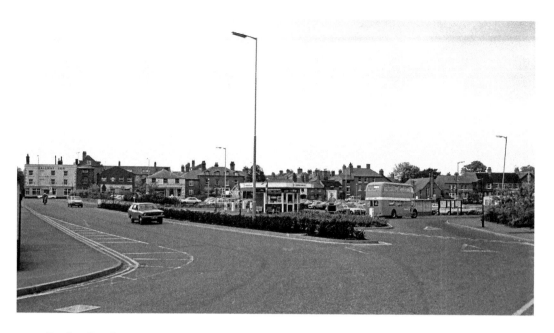

Station Road

The older view shows Station Road looking up to the Railway Inn on Beatrice Street, before the roads in the area were realigned. To the right, looking towards the Gobowen Road, is the bus station and car park. The building behind the lamp post is the Crosville Bus Co.'s information and booking office. The company started their first bus service in 1909 between Chester and Ellesmere Port. By 1929 they were running services in the Wirral and to parts of Lancashire, Cheshire and Flintshire, and, by the 1930s, Oswestry and North Wales. The dark red and cream buses on the modern view belong to Tanat Valley Coaches, a family-run firm on the border of Shropshire and Wales. The red car is coming down Station Road, which is now part of Asda.

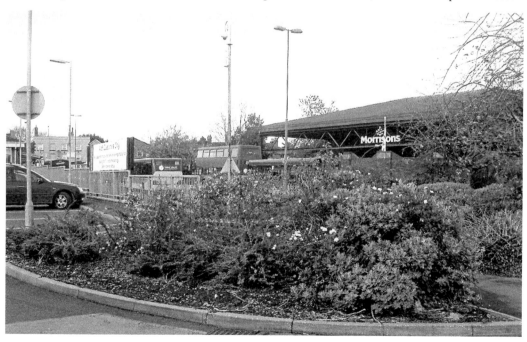

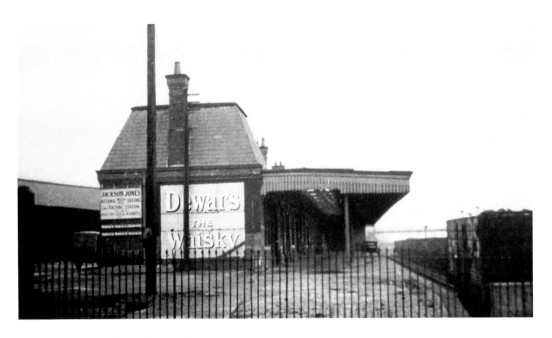

Great Western Railway Station, Station Road

The Great Western Railway station was located close to the Cambrian station, just south of Beatrice Street on Station Road. The first railway entered Oswestry in 1848 on a line branching off at Gobowen from the Shrewsbury to Chester Railway. This station replaced an earlier one in 1866. When the Cambrian Railway was taken over by the Great Western Railway in 1922, all passenger services were transferred to the larger Cambrian station, this one being used for freight until its closure. The station was demolished in 1973 and a Gateway supermarket was built on the site. Note the adverts for Dewar's Whiskey and for the National Mark egg-grading and -packing station, belonging to Jackson Jones. The site is now occupied by Morrisons and covers an area that was once packed with sidings, goods sheds and cattle pens.

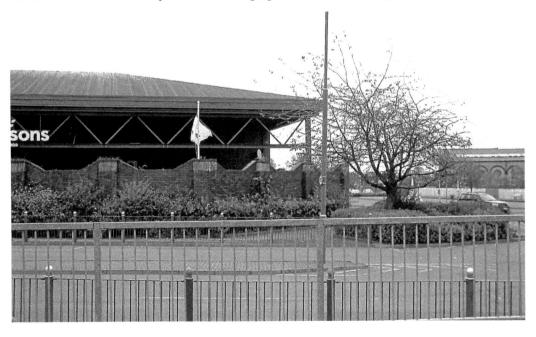

The Railway Inn

The Railway Inn is situated in Beatrice Street, looking directly down Station Road towards the Cambrian and Great Western Railway stations. It was first licenced in the mid-nineteenth century and was later enlarged in this style by demolishing a maltings next door. In 1900, it was occupied by Thomas Davies, who was also owner and landlord of the Bell in Church Street. He employed a manager named John Howell, who was reputed to keep the inn clean and in good repair. At this date it was known as the Railway Tavern and was tied to selling beer from Dorset Owen & Co. Brewery. The opening to the left of the inn is Swan Lane, which takes its name from the New or Lower Swan Inn that was first licenced in the 1850s. In the 1980s, the Railway Inn sold Border Ales, but apart from that and the name at the top of the building being removed, very little else has changed; however, the building to the right has had the top two storeys removed.

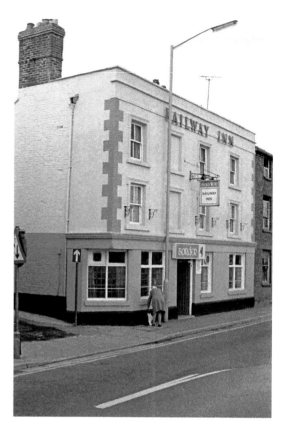

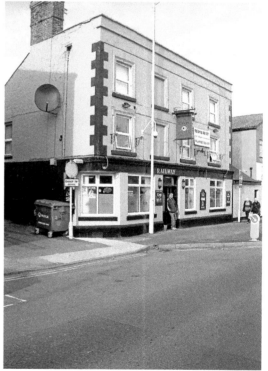

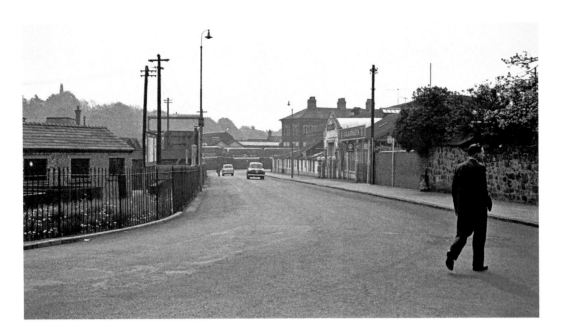

Station Road

The photographer has his back to the Railway Inn and is looking down Station Road towards the Cambrian railway station. Just in front of which, with the round roof, is the Crosville Bus Depot. Taking up all the area on the left is the Great Western Railway station and sidings, and above in the distance is Shelf Bank, which looks over the Cambrian Works. The road has now become part of the bus station, which is flanked on either side by Morrisons and Aldi supermarkets. The only recognisable feature on either photograph is the Cambrian station – located at the bottom on Oswald Road.

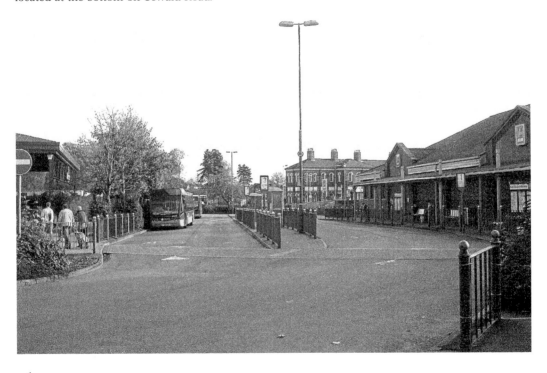

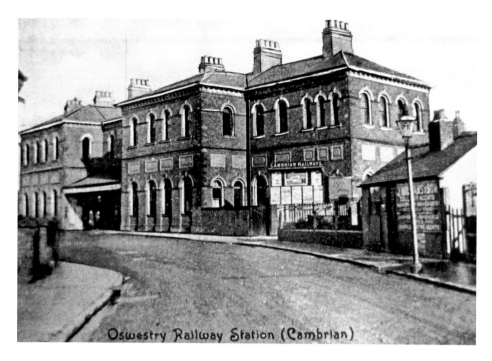

Oswestry Railway Station (Cambrian)

Cambrian Railway Station

The old view of the Cambrian railway station in Oswald Road was taken around 1918. The Cambrian Railway was formed in July 1864 when a number of smaller railway companies from north-west Shropshire and North Wales amalgamated. Their first headquarters were in Welshpool, but by the end of the decade the company had moved to Oswestry. A date stone at the far end of the station shows the year '1869'. The company brought a great deal of prosperity to the town by opening a large locomotive, carriage and wagon works that employed hundreds of men. In recent years the station has been renovated and now houses the Cambrian Visitors Centre, the Station Pharmacy, a restaurant and offices. The modern view shows that apart from the demolition of the outbuilding to the right, the loss of the gas lamp, and the emergence of the motor car little else has changed.

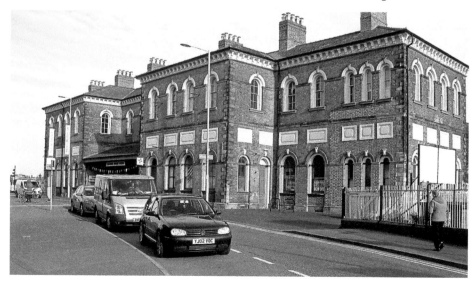

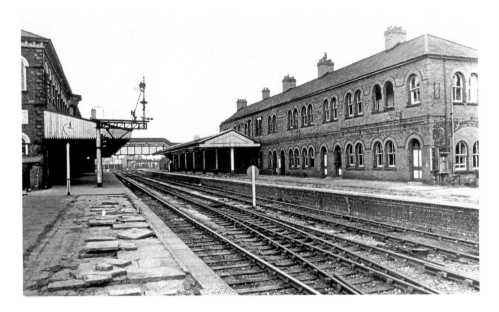

Cambrian Railway Station

This view of the inside of the Cambrian station was taken in March 1971, when the empty buildings were falling into disrepair. The photographer is looking towards the Cambrian Works, which is off to the right, hidden by the station buildings. The lines going out led to Gobowen, Ellesmere and Whitchurch. The line to Whitchurch closed to passengers on 18 January 1965, while the line to Gobowen closed the following year on 7 November. The last passenger train to leave the station was pulled by No. 7822 Foxcote Manor. The single line connecting Gobowen to the quarry at Llanyblodwel was used by freight trains through to 1988. The footbridge linking the platforms at the far end of the station has been dismantled and the extensive buildings on the right demolished. The distinctive GWR canopy over the platform has also disappeared but the signal gantry is still in situ.

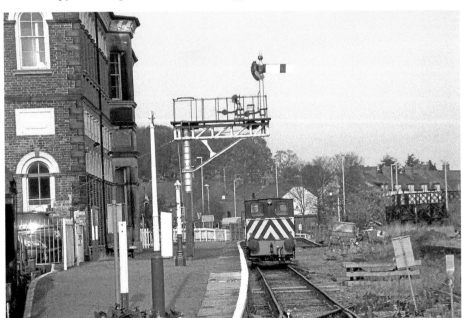

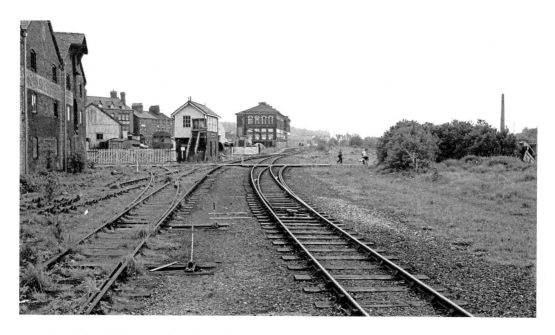

Cambrian Railway Station from the South

The photographer is looking north-east towards the Cambrian station with the Oswestry South signal box still in situ. The signal box was given Grade II-listed status in May 1986 and complete restoration work began on it in 2017. The chimney (to the top left) is part of the Cambrian Works. Most of the track was lifted by British Rail in 1972, along with the demolition of the buildings and platform on the down line. The modern photo, taken a few metres to the right of the old one, shows that a great deal of railway land has been built on and that a footpath has been inserted where track once stood. A walkway over the track, just in front of the signal box is still open to pedestrians.

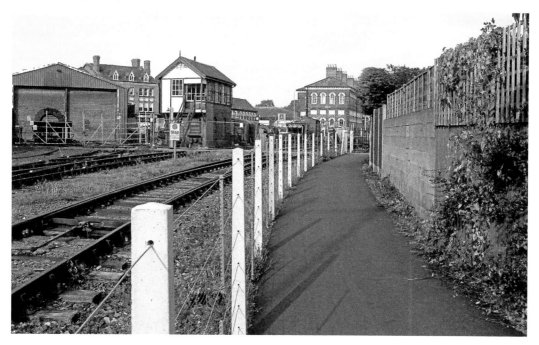

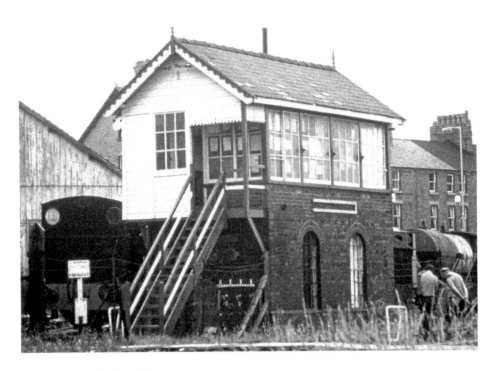

Oswestry South Signal Box

Oswestry South signal box was built in the 1860s and had a very busy working life until the close of the railway. It was full of levers that would direct traffic on to the main-line rails or into the numerous sidings and bays that surrounded the station. After the closure, the box was stripped of all its working items and the empty shell left to decay. After the Cambrian Railway Trust was formed it was used by the society as a meeting room and a canteen. As of 2017 the box was being renovated and refurbished, and has just been fitted with a set of levers from the old signal box at Baschurch.

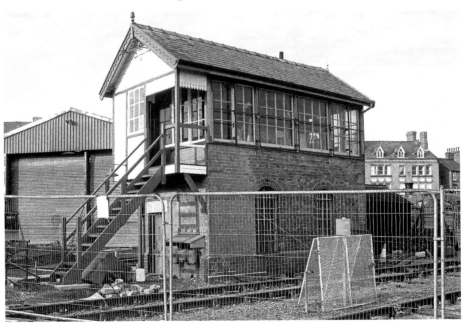

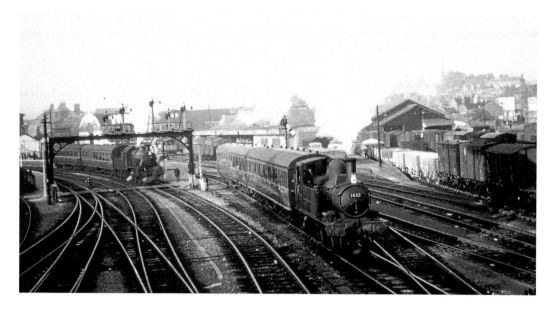

Oswestry Railway

The old view was taken from the footbridge that took workers across the track to the Cambrian Works in the heyday of steam in Oswestry. The photographer is looking back towards the old Great Western station on the right, with the main Cambrian station on the left. On the extreme right are sidings, goods sheds and animal pens. The engine No. 1432 is a tank engine, used mainly for pushing and pulling trains on short branch lines; they were nick-named 'Bobtails' by Great Western drivers. The train is leaving the bay in the main station and heading towards Gobowen. In the modern view, the entire track has been lifted and the land redeveloped for car parking and retail businesses. The Cambrian station can just be seen through the branches of the tree on the left.

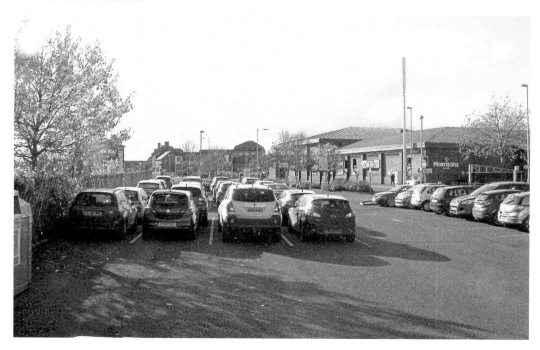

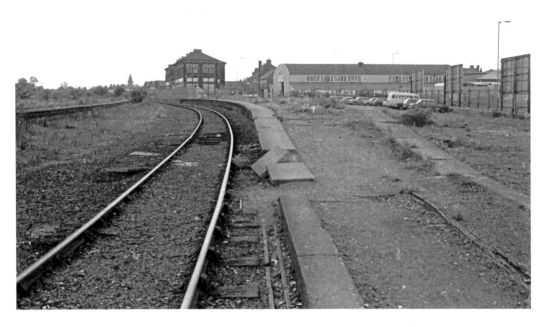

Cambrian Railway Station from the North

The old view was taken in 1980 and is looking back towards the Cambrian station after the demolition of the buildings to the left of the track. The old Great Western station has also been demolished and would have stood roughly just to the right of where the cars are parked. Most of the track has also been lifted, leaving just one line going through the station. The Cambrian Heritage Society hope to open the line, running trains to Llanyblodwel and back to Gobowen to link up with the main line. The building to the right of the station with the round roof, was built as a roller-skating rink in 1909. It was then used as a drill hall before becoming a bus depot for Crosville buses around 1933. The site is now occupied by Aldi car park and part of the bus station.

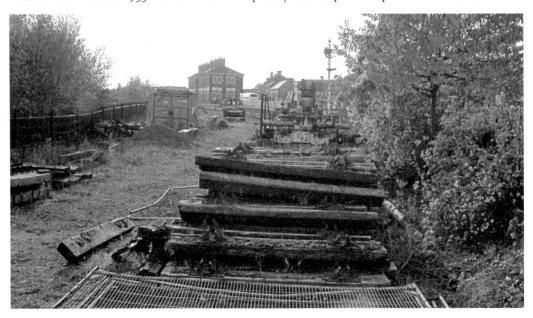

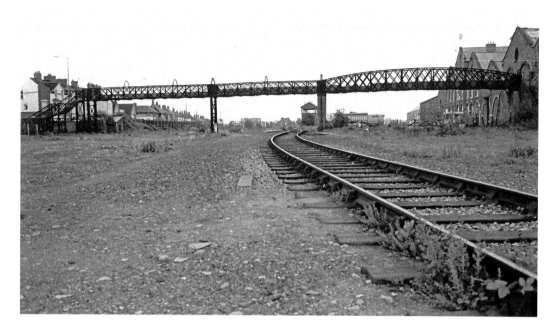

Cambrian Works Footbridge

This view looking in the opposite direction to the last photograph, was also taken in 1980. The footbridge would have taken workers who lived on this side of the track to the Cambrian Works on the right. Just under the footbridge is Oswestry North signal box, the town's biggest signal box, which was demolished some years ago. Only one track remains on both photographs, but today the space left has been used to realign the road and for car parking. The houses still standing on the left, at the corner of Llwyn Road, were built in 1900. The footbridge remains, but was closed off at both ends for safety reasons in September 2014. It's around 60 metres long and made from wrought-iron lattice trusses that rest on two cast-iron columns and a brick pier. Together with the Cambrian Works, it was given Grade II-listed status in May 1986.

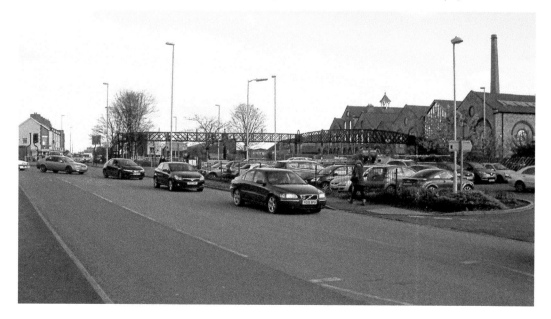

Boiler Shop

CAMBRIAN RAILWAYS.
(INCORPORATED with G.W.R)
VIEWS of WORKS

Carriage Builders' Group

Cambrian Works

The Cambrian Works is a red-brick building that was erected between 1865 and 1866 at a cost of £28,000. The works had a network of tracks giving access to all areas, which included boiler, paint and machine shops as well as a foundry and carriage builders department. The new works brought in hundreds of workers to the town, and between 1861 and 1901 the population of Oswestry almost doubled from around 5,550 to nearly 10,000. Although the works maintained all the rolling stock and built hundreds of carriages and wagons, only two locomotives were fully constructed there. The company was taken over in 1923 by the Great Western Railway and was closed by British Rail on 31 December 1966. In 2011, after a great deal of renovation, the Oswestry Health Centre opened in part of the building and also a large antique centre called the Cambrian House Emporium. Other space in the building is taken up by Carriages, a smart wedding venue, restaurant and bar.

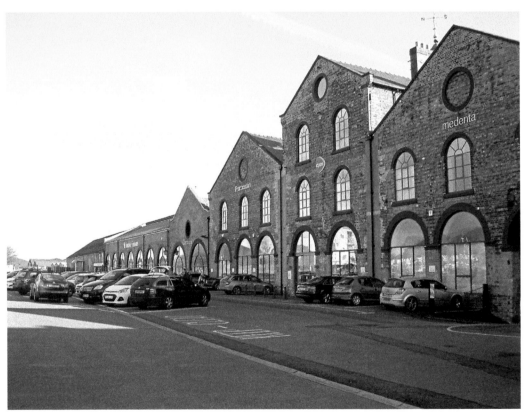

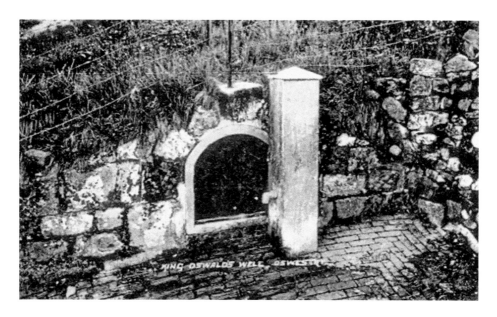

St Oswald's Well

St Oswald's Well is situated in Upper Brook Street. Oswald was a Northumbrian king who was killed while fighting against King Penda of Mercia in the seventh century at the Battle of Maserfield. His head and arms were removed by Penda and impaled on spikes. According to local legend, a large bird swooped down and removed one of the arms and flew into a tree. The tree became known as Oswald's Tree, giving the town its name. The bird then dropped the arm and a spring appeared where it fell, containing healing qualities. The town council began a scheme to tidy and improve the well and surroundings, which was completed in 1985. A statue of an eagle holding the arm of Oswald has been installed just above the well.

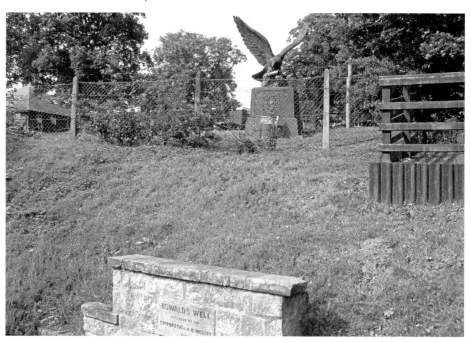

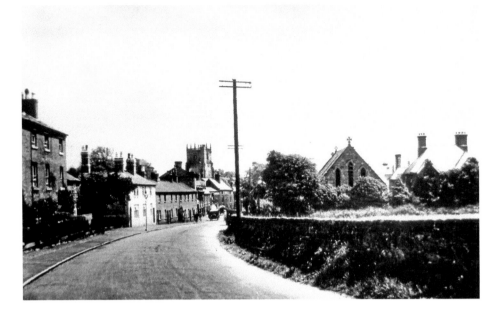

Upper Brook Street

The older photograph of Upper Brook Street, from around 1930, is looking back towards the town. In the centre of the view is the tower of St Oswald's Church. The building on the right with crosses at either end of the roof is the Catholic church. The church was dedicated to Our Lady the Help of Christians and St Oswald, and was paid for by Mr T. Longueville, a local solicitor. The church was built out of stone in 1890 in the Early English style and could seat 230 people. The sanctuary was decorated from designs by J. A. Pippet of Solihull in 1897 and a porch was added in 1899. The presbytery was built out of red brick and attached to the chancel, and a separate block forming a convent and an elementary school was built at the side. In the modern view, the left-hand side looks virtually the same, but on the right the open area above the church is now occupied by retirement homes.

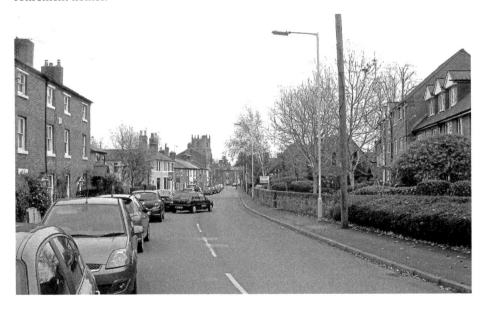

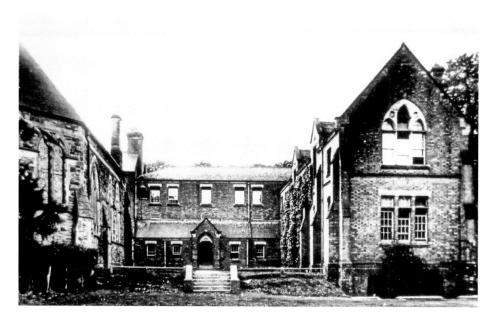

Oswestry School

The first view of Oswestry School in Upper Brook Street was taken around 1920. The school was founded in 1407 by David Holbache and was rebuilt here in 8 acres of parkland in 1781. The school was enlarged and partly rebuilt in 1879 to include a large schoolroom, library, dormitory, classrooms and sickbay. The chapel on the left was erected in the Early English style in 1863 for around £1,400. It contains several memorial windows of former pupils and an organ in memory of Colonel Burnaby. Cricket and football pitches were also laid out in an 18-acre field next to the school. Very little has altered over the years, apart from the ivy being removed from the one wall, the bushes on the right taken up to reveal two entrances to a cellar, and the area in front of the school being tarmacked.

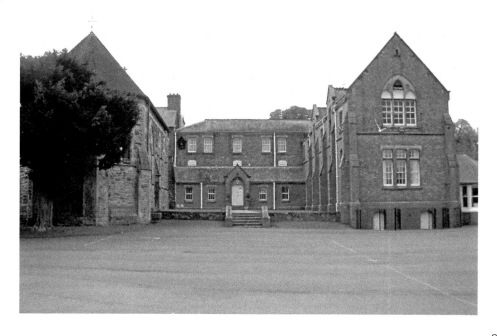

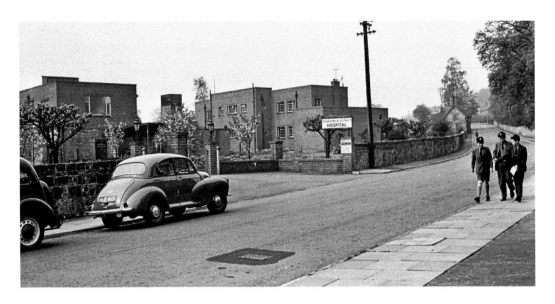

Oswestry Cottage Hospital

Oswestry's first Cottage Hospital was opened in 1866 on Welsh Walls and had seventeen beds. It was rebuilt in 1870 and contained twenty-one beds, and an isolation hospital was erected in 1895. A new Oswestry and District Hospital was erected here on land just above the Catholic Church in Upper Brook Street in 1939. It was described in Kelly's Directory as 'the modern well equipped buildings contain 35 beds: there are X-ray and operating theatres, and a nurses' home adjoining'. The hospital was closed in 1991 and replaced by houses and retirement homes on Lutton Close. The land above the hospital has been laid out as a sports field for Oswestry School, and the building on the roadside that was once a toll house is now used by the school as a bursary and delivery office.

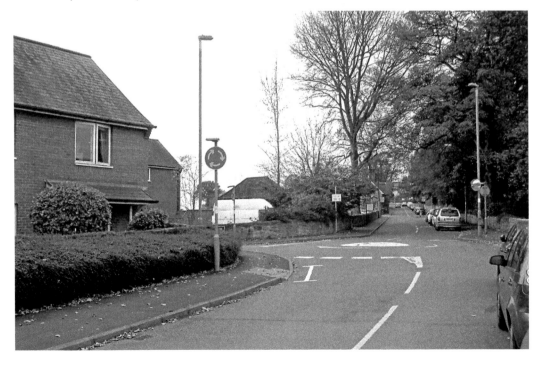

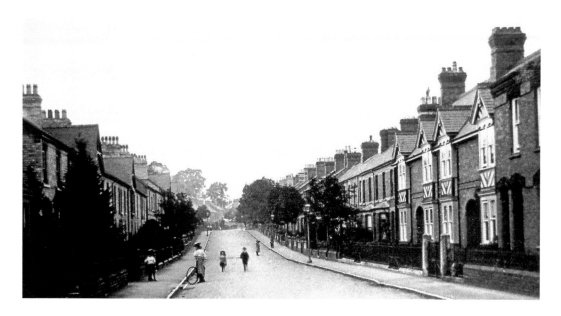

Park Avenue

The photographer has his back to Welsh Walls and is looking down Park Avenue, towards Mount Road. In 1795, the land on which the Avenue was built belonged to Robert Lloyd of Swan Hill and Revd George Warrington. Robert Lloyd later acquired the whole site – around 8 acres – which was then purchased by Edward Jones of Brook Street House around 1875. After planning the street layout, Jones sold the land for building. The Avenue takes its name from the nearby Brogyntyn Park. It is lined with these substantial Victorian dwellings, which would have housed the wealthier middle-class families of the town. One of the residents living at No. 38 in 1920 was Isaac Watkin, who wrote a history of the town, called simply *Oswestry*. In the distance on the new view is Oswestry fire station at the junction of Mount Road. Very little has changed, apart from the problem of the twenty-first century car parking.

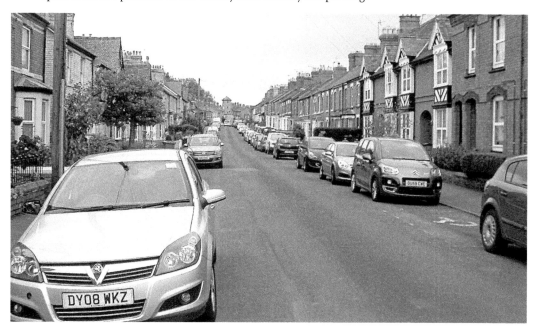

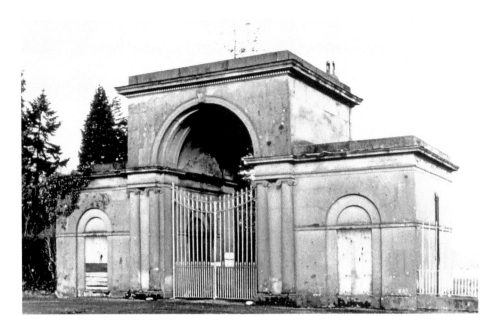

The Lodge, Mount Street

This is the Lodge on Mount Street, which used to be one of the entrances into Brogyntyn Hall. The hall dates back to around 1730, but was greatly enlarged between 1813 and 1820. The main entrance to the hall is noted for its four fine Ionic columns and ornamented pediment. The estate, which covered over 1,000 acres, was the former home of Lord Harlech. The Ormsby-Gore family lived there from 1815 until the mid-1980s, and it was sold by the 6th Lord Harlech in 2001. The lodge was once occupied by the gatekeeper, but has been uninhabited for many years. The building and the gates are Grade II listed, but in 2009 the section over the main entrance was removed, leaving just the arch. Ivy has also been allowed to grow over the old boarded-up windows.

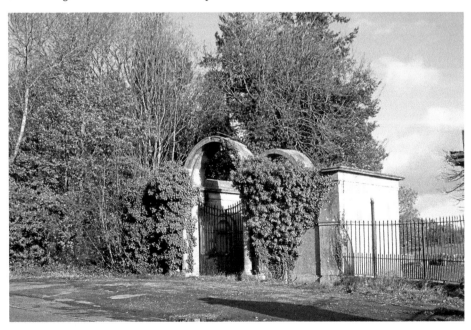

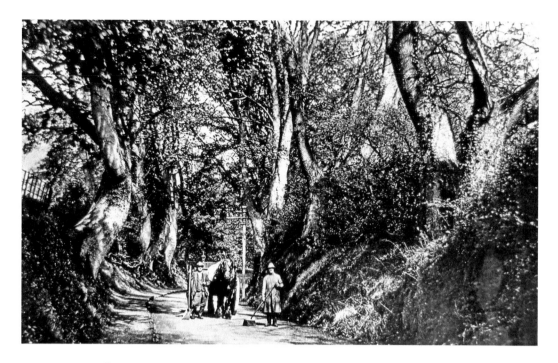

Broom Hall Lane

Two street cleaners pose with their horse and cart in Broom Hall Lane around 1920. The lane runs off from Upper Brook Street and takes its name from Broomhall, which was situated there. In 1855, the hall was described as 'among the more attractive residences in the immediate suburbs of the town'. At this date it was occupied by Mrs Aubrey, the widow of Henry Aubrey, who between 1811 and 1814 was in charge of nearly 300 French prisoners of war based on parole in Oswestry. The modern view shows that little has changed, apart from the trees being thinned out and the road and pavement being made up. Some very nice modern houses have been built near the town end of the lane.

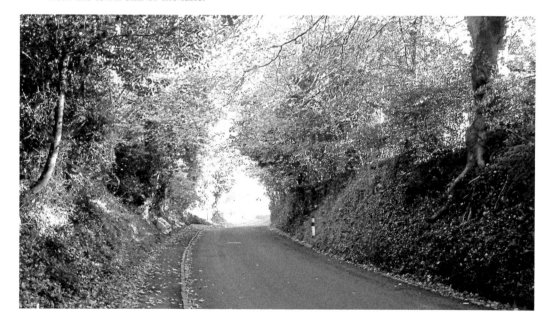

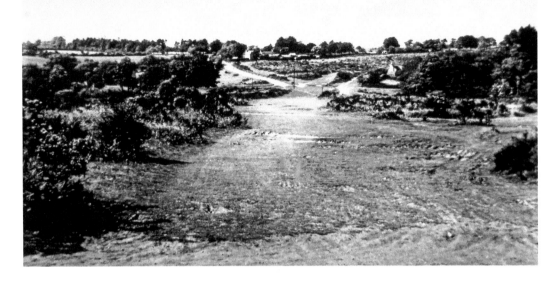

Oswestry Racecourse

The Racecourse lies just outside the town on a hill known in Welsh as Cyrn y Bwc – 'the Ridge of the Buck'. Standing at just over 1,000 feet, you have spectacular views over the town to Cheshire, Derbyshire, Staffordshire and west to the mountains of Wales. The course, which is still visible, is like a figure of eight that intersects at the middle of the road. That intersection was known as 'The Chains,' derived from the chains that were hung across the road to close it during race meetings. A full circuit of the track was 1.75 miles. The last race meeting was held there in 1848. The two-headed statue is the work of sculptor Mark Evans and is known as *The Janus Headed Horse* after the Roman god. It is placed so that one head looks across to Wales and the other looks across Shropshire. In the distance is the ruin of the old grandstand, built at the beginning of the nineteenth century and sited close to the finishing post. The course covers around 54 acres and is a favourite place for ramblers and dog walkers.

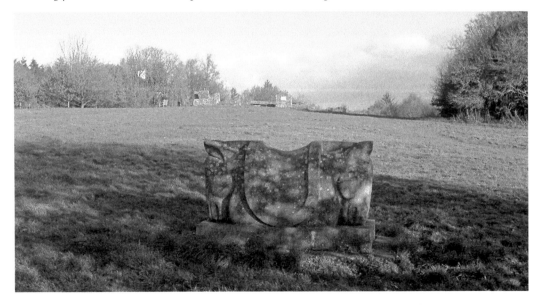

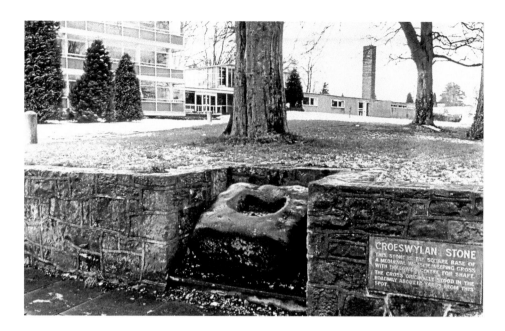

The Croeswylan Stone

This school on the corner of Morda Road and Croeswylan Lane was built in the 1960s and was known as Oswestry Boys' Modern School. After several amalgamations with other schools, the Marches School was formed in September 1988 – ten years after the older photograph was taken on 22 February 1978. There has been very little change between the two photographs; some fir trees have been removed and shrubs planted. The large stone in the centre is the Croeswylan Stone, which was the base of the Weeping or Wailing Cross. It's a large sandstone block with chamfered corners and a hollow centre used as a base to hold a stone cross upright. It's believed to have stood in the road around 12 metres from its present position, and is thought to date from the fifteenth century. It was placed in this position and preserved in 1890.

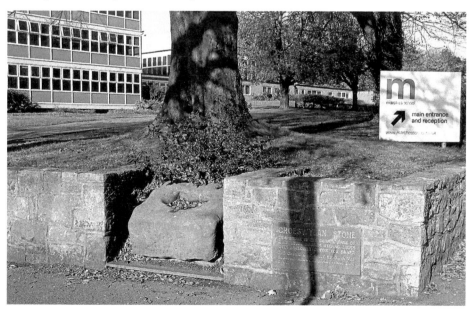

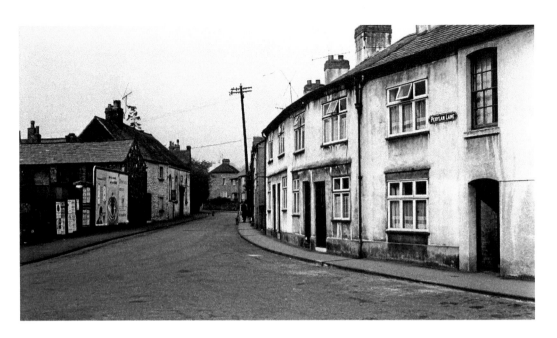

Penylan Lane

Penylan Lane turns off from Upper Church Street and heads towards the Marches School and playing field. The building on the left with the rounded windows was marked on the 1901 Ordnance Survey Map as a 'Mission Room'. It was built in 1856 by the Welsh Methodists, who moved to a larger chapel in Victoria Road in 1878. It later became a Catholic church dedicated to St David. In the nineteenth century, a chain gate crossed the road at this point, which used to hamper farmers bringing cattle into the town from that direction. The building on the left, behind the hoardings, has been converted into a launderette in the modern photograph.

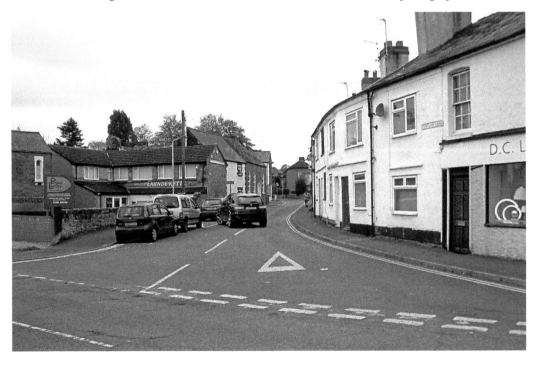

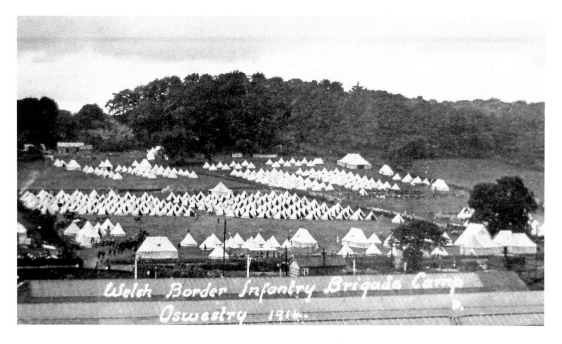

First World War Camp, Gobowen Road

The first photograph was taken just after the outbreak of the First World War, when a temporary camp was set up opposite the Cambrian Railway Works on the Gobowen Road for men of the Welsh Border Infantry Brigade. Within days, over 4,000 troops arrived from four Territorial Regiments – the 1st, 2nd and 3rd Monmouth Light Infantry and the 1st Hereford Light Infantry – to form the Brigade, which was under the command of Brigadier-General Hume. The area they used adjoined the Agricultural Show Ground, situated under Oswestry Coppice. The camp was there for less than a month as the troops departed overnight by rail at the beginning of September. Both photographs are taken from Shelf Bank, with the roofline of the Cambrian Works immediately below. The area once covered by tents is now covered by housing.

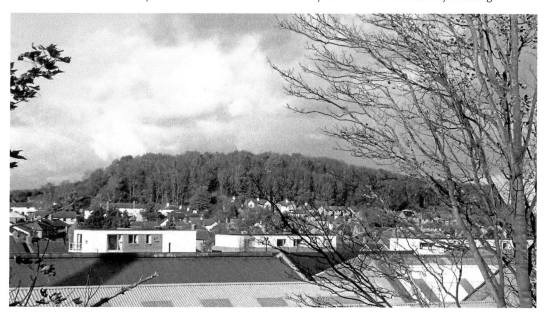

Acknowledgements

I am very grateful to a number people who have loaned and given me so many photographs for my collection of our beautiful county of Shropshire. For this volume, my particular thanks go to the Madin family of Abbeycolor, who let me copy views from their collection, and to the *Shropshire Star* for allowing me access to their large archive. I would also like to thank David Benson, Peter McConville and the late Len Davies for the copies of postcards and photographs they let me have. I am also indebted to Richard Mellor for accompanying me around Oswestry on my first visit and literally pointing me in the right direction to take the modern views. Also to Dave Wood, for directing me to a more obscure site that I had difficulty in locating, and to Charles Powell for information about the railway. I would also like to thank my wife Wendy for reading through the text and for all her help and encouragement. Lastly, I would like to thank the people of Oswestry for making my visits so enjoyable and for being so helpful and friendly as I walked around the town taking the modern views.